G000077526

BRENTFORD

THROUGH TIME

Gillian Clegg

AMBERLEY PUBLISHING

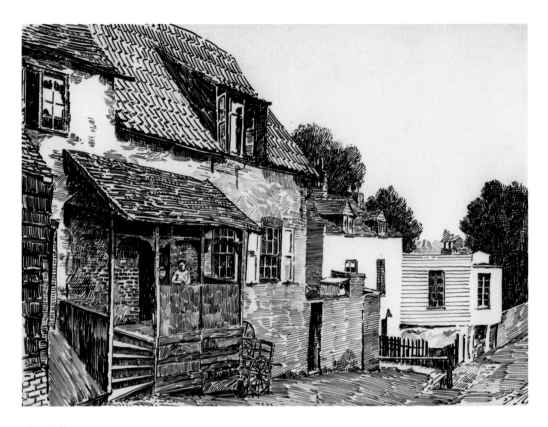

The Hollows
Old cottages in the Hollows, the passage way from Watermans Park to the High Street beside O'Riordan's pub.

To Patrick, with thanks for his help and his patience.

First published 2011

Amberley Publishing
Cirencester Road, Chalford,
Stroud, Gloucestershire, GL6 8PE

www.amberley-books.com

Copyright © Gillian Clegg, 2011

The right of Gillian Clegg to be identified as the
Author of this work has been asserted in accordance
with the Copyrights, Designs and Patents Act 1988.

ISBN 978 1 84868 905 3

All rights reserved. No part of this book may be
reprinted or reproduced or utilised in any form
or by any electronic, mechanical or other means,
now known or hereafter invented, including
photocopying and recording, or in any information
storage or retrieval system, without the permission
in writing from the Publishers.

British Library Cataloguing in Publication Data.
A catalogue record for this book is available from
the British Library.

Typeset in 9.5pt on 12pt Celeste.
Typesetting by Amberley Publishing.
Printed in the UK.

Introduction

Today, Brentford is just one of many London riverside suburbs so it might come as a surprise to learn that it was once one of the most important towns in Middlesex. It was where people from all over the county came to vote for their Parliamentary MPs, and where justice was dispensed in the courts. It boasted a famous fair and a weekly market and is mentioned in books by many famous writers – Ben Jonson, Samuel Pepys, Walter Scott, Thackeray, Shakespeare and Dickens among them.

Brentford's rich history starts early – in prehistoric times with many ancient artefacts recovered within the area. There was a ford across the Thames which, it has been claimed, was used by Julius Caesar in 54 BC when he invaded Britain. Later, Brentford was a Roman village along the main Roman road from London to the west of England; Saxon kings and bishops held meetings in Brentford, and in 1016 King Edmund chased Canute and his Viking army across the Thames here. A famous battle took place in Brentford in 1642 during the English Civil War where the Royalist army defeated the Parliamentarians and ransacked the town.

Famous people associated with Brentford include the American Indian princess Pocahontas who lived here with her husband John Rolfe for a short time in 1616. They are thought to have stayed in a house which stood where the Royal Mail sorting office is today, and it was in a building on the same spot that Percy Bysshe Shelley was a pupil when it was the private Syon House Academy. Artist, J. M. W. Turner was also educated in Brentford during the years he lived with his uncle in a house that stood next to the White Horse pub (now the Weir) in Market Place; John Quincy Adams, the future 6th President of the United States, rented a house in Brentford when he was American Minister in Britain from 1815 to 1817.

Industry was attracted to the town due to its position on the main road to the west of England and at the conjunction of the rivers Thames and Brent. The latter was canalised in 1794 to form part of the Grand Junction (later Grand Union) Canal and a dock and railway line were constructed to enable goods to and from the hinterland to be transported to the London docks. There were all sorts of industries – distilleries, breweries, potteries, soap works, tanneries, flour mills, lime kilns, turpentine works, jam makers, timber yards, barge and boat builders, a water works and a gasworks. 'A bit of Black Country stuck there by the shores of the ancient Thames' is how Francis Watts described Brentford in 1890. Most of the inhabitants lived in small cottages crammed into a maze of courtyards and narrow alleyways and were thus susceptible to illnesses like the plague – 200 Brentford folk died in the plague of 1665 – and cholera. Brentford had so many pubs that one journalist nicknamed it 'the town of taverns'.

There were some grander houses, notably the enclave known as the Butts and there were large mansions – Boston Manor, home to the Clitherow family from 1670 until 1923 and Gunnersbury Park which belonged to the Rothschild family from 1835 to 1925.

Arranged in a loose chronological order, this book aims to give you a glimpse of Brentford past and present. It contains over 180 images – old pictures juxtaposed with modern photographs of the same or similar views today. Some of the old illustrations are prints and paintings, rather than photographs, since Brentford was an important place long before the invention of photography.

Brentford may have been more picturesque in earlier times than it is today, but by the nineteenth century it was a dirty, noisy place, also smelly from the noxious odours produced by the gasworks, tanneries and soap works. Now, the green space of Watermans Park covers much of the gas works site. The Ferry Quays flats stand where the soap works used to be, the Island Development replaces an old tannery and the waterworks is now the Kew Bridge Steam Museum. When (and if) it goes ahead, the long awaited redevelopment of a large chunk of land south of the High Street should see the abandoned warehouses, derelict buildings and scruffy 1950s shops replaced by what is to be hoped will be more interesting architecture so that Brentford will become picturesque once more.

The Roman Road

These shoppers in Morrisons are perhaps unaware that beneath their feet lies the main Roman road from London to the west of England. Brentford was a small village in Roman times. The older photograph shows archaeologists digging the surface of the road in 1974/5 in the garden of 232 Brentford High Street (the old Feathers pub), now incorporated into the supermarket.

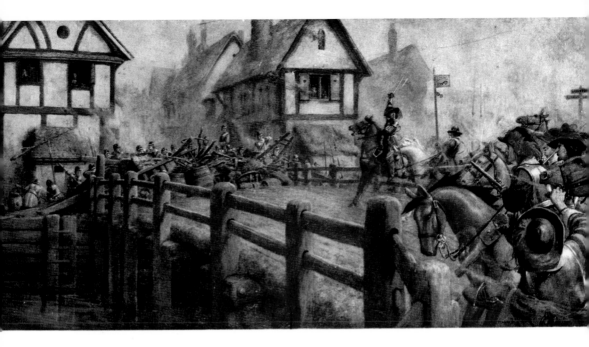

The Battle of Brentford

In November 1642, during the Civil War, a fierce battle took place in Brentford with the Parliamentary forces trying to prevent the Royalist Army marching on London. However, the Royalists won through and ransacked the town. The old picture, painted in 1928, is artist John Hassall's impression of the battle for the bridge. The modern photograph shows the plaque on the bridge which commemorates the event.

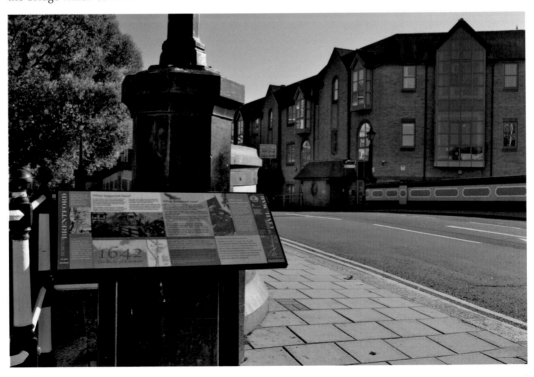

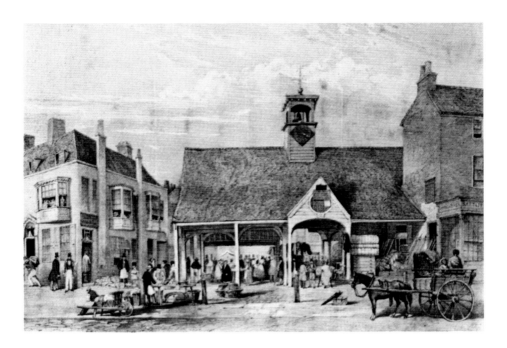

The Market House

This stood in the Market Place where a weekly market was held from 1306 until 1933. To its left is the Three Pigeons pub (see p 64). The Market House was demolished in 1850 to make way for the building which was to become the Magistrates' Court. The new photograph shows an event held in Market Place to celebrate St George's Day in April 2010. Robert Rankin is signing copies of his book.

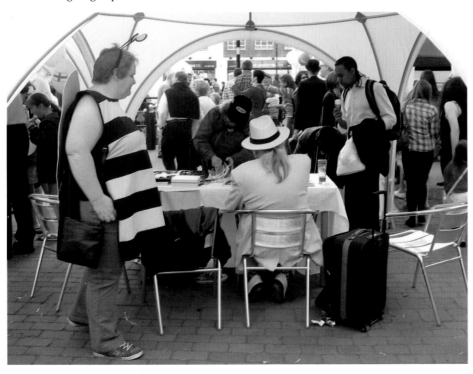

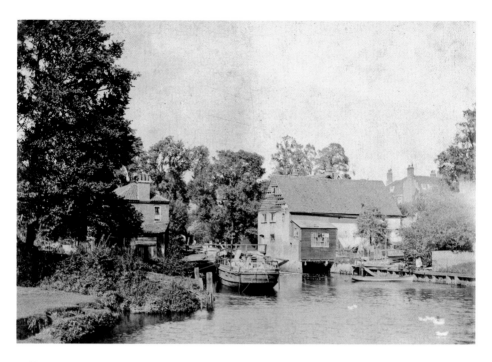

Mill on the Brent

A watermill was built on the River Brent in 1738. This 1900s view is from the Island, which from 1929 to 1997, was used as a depot for transporting cargo between canal and river, and later river and road. The watermill was demolished to make way for the Boatmen's Institute, the rear of which can be seen on the right of the modern photograph. A housing development has been built on the Island.

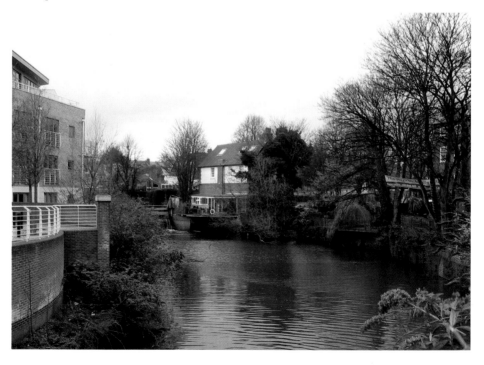

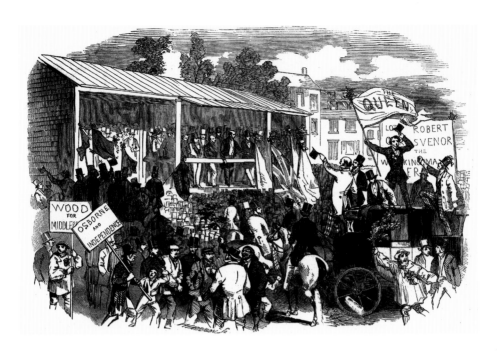

Middlesex Elections

In the eighteenth century polling for the parliamentary candidates for Middlesex took place in the Butts. They were noisy, congested affairs, often rowdy and boisterous; the election in December 1768 resulted in riots, bloodshed and death. Tranquil though it is today, Protestant martyrs were burnt at the stake here in 1558 and the Royalist Cavalry was stationed in the Butts during the Battle of Brentford in 1642. The building in the modern photograph was the Cottage Hospital between 1893 and 1928.

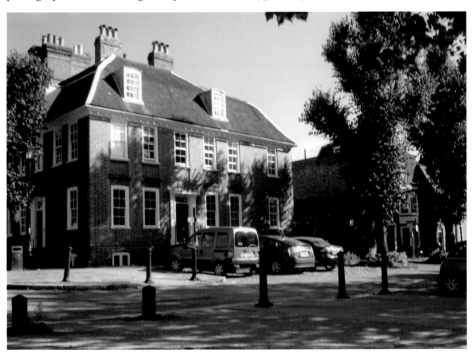

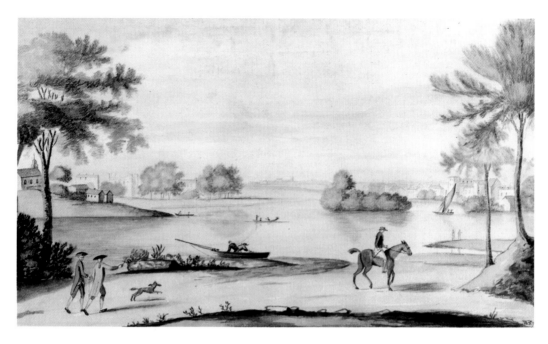

The Thames at Brentford

The eighteenth-century painting shows how much wider and shallower the river was before its banks were built up. There was a ford across the Thames at Brentford where Julius Caesar is said to have crossed the river when he invaded Britain in 54 BC. In 1016 King Edmund Ironside chased Canute and the Danish army across the river in Brentford, twice.

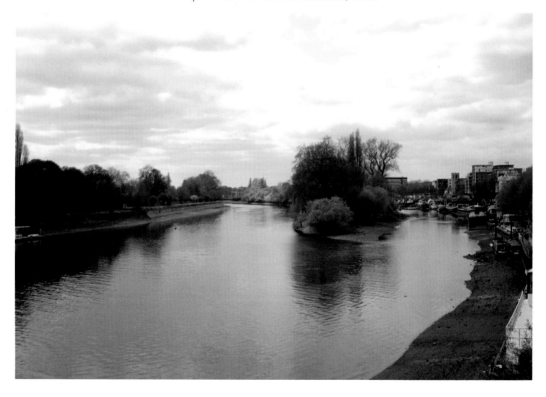

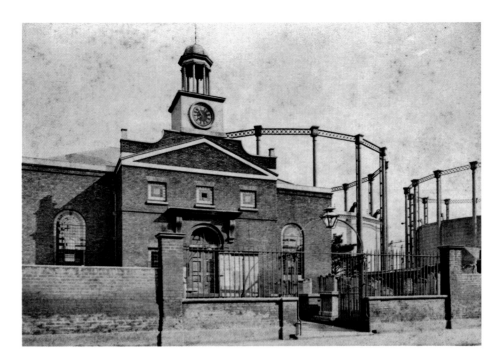

St George's Church

The old photograph, taken *c.* 1880, shows the first St George's Church, in the shadow of the gasometers. The church, designed by John Joshua Kirby, was erected in 1766 as an unconsecrated chapel for fifty-seven prominent Brentford residents. It was replaced by the much larger church shown in the modern photograph which was designed by Arthur Blomfield in 1886/7. The tower was added in 1913. The church closed in 1959 and from 1963 to 2009 was home to the Musical Museum.

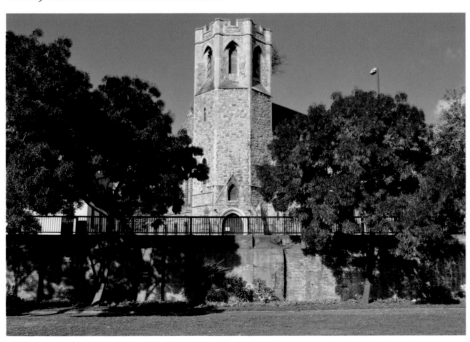

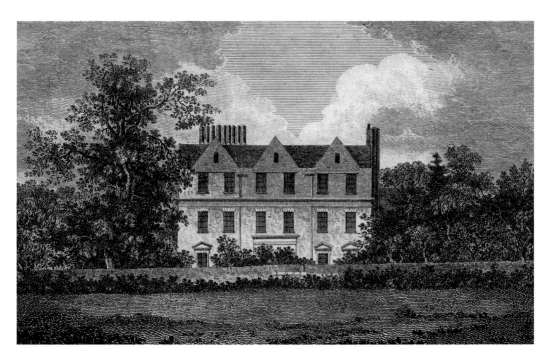

Boston Manor House

The old picture shows the house in 1799. It had been built in 1622 on the land of an earlier manor house which had once belonged to Queen Elizabeth I's favourite, the Earl of Leicester. The Clitherow family, who lived in the house from 1670 until 1929, made many alterations, although they are not really visible in the modern photograph.

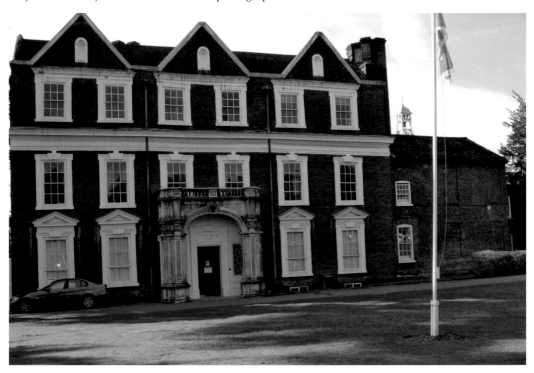

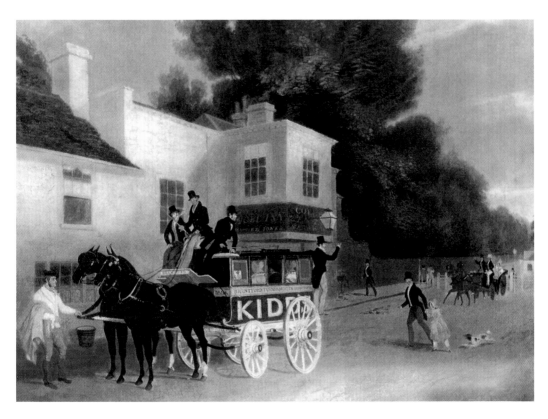

The Angel Inn

The early nineteenth-century painting by James Pollard shows this old Brentford coaching inn. Beyond it is the Brentford tollgate where people paid their dues to use the road. The modern photograph shows the flats called Syon Court, built in about 2004, on the site of a pub called the Park Tavern which replaced the Angel.

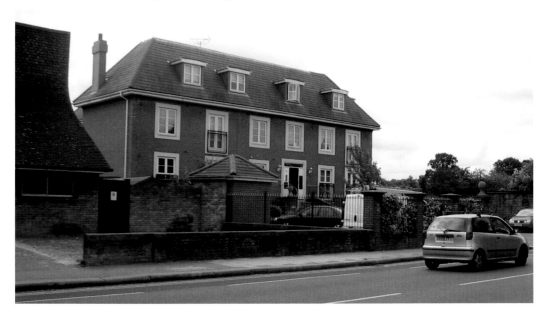

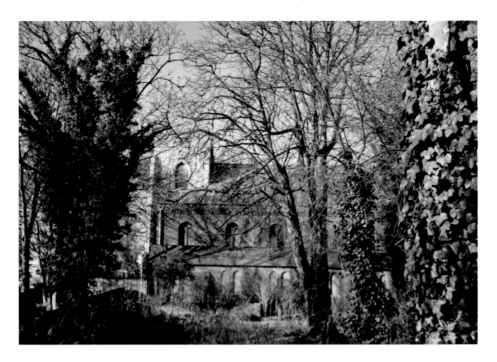

St Lawrence's Church

This 1809 engraving by S. Woodburn shows the church from the south. Its tower built in about 1480 is the oldest structure in Brentford. The church itself was rebuilt in 1764 and closed in 1961 when the various Brentford parishes were combined. The gravestones have been taken up and the church itself has stood forlorn and neglected for over forty years, despite various schemes to turn it into a theatre or restaurant.

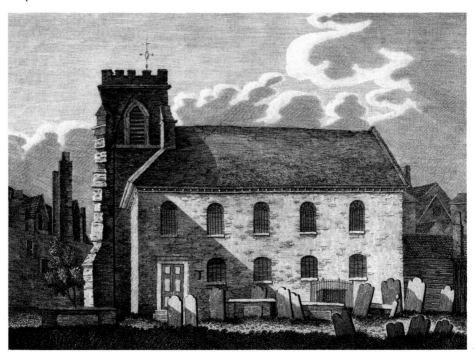

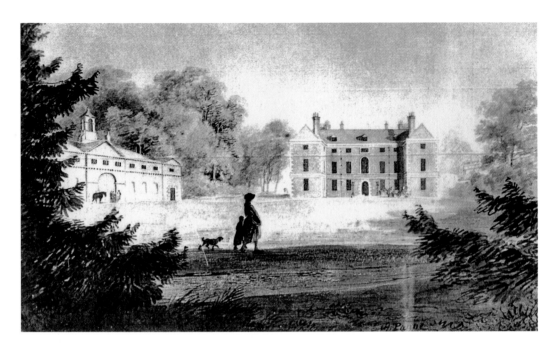

Gunnersbury Park

The house in the old picture once stood in Gunnersbury Park. Designed by John Webb and built around 1660, it was demolished in about 1802 and replaced by the present two Gunnersbury mansions. The modern photograph shows Gunnersbury Park, the Large Mansion, which was one of the homes of the Rothschild family between 1835 and 1925 and is now the Gunnersbury Park Museum.

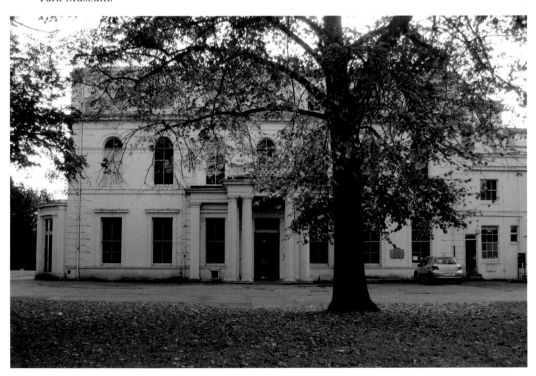

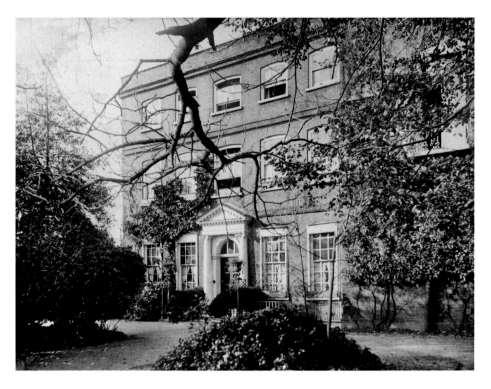

Syon House Academy

The house in the old picture was the private boarding school attended by poet Percy Bysshe Shelley in 1802 when he was ten years old. He stayed for two unhappy years. The school closed in about 1820 and became a private house. This was demolished in 1953 and the Royal Mail Delivery Office was built on the site in 1992. It was opened by local resident Anna Ford.

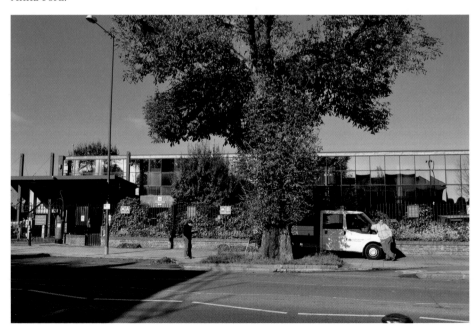

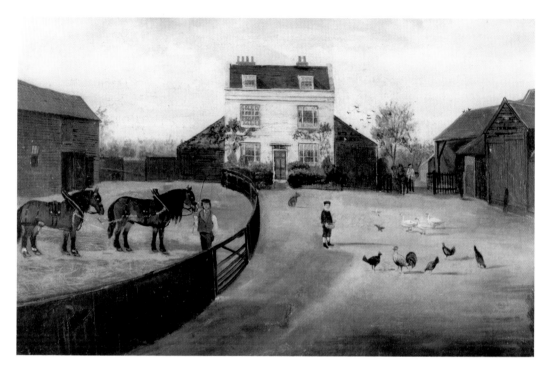

London Stile Farm

The mid nineteenth century oil painting shows London Stile Farm which stood somewhere near the site of the Fountain Leisure Centre which is shown in the modern photograph. In 1893 the Fruit and Vegetable Market (see p 42) was built on the farm's land and was there until 1974. The Fountain Leisure Centre was opened by Neil Kinnock in 1987.

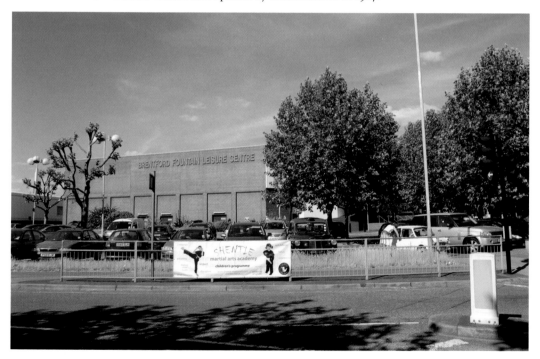

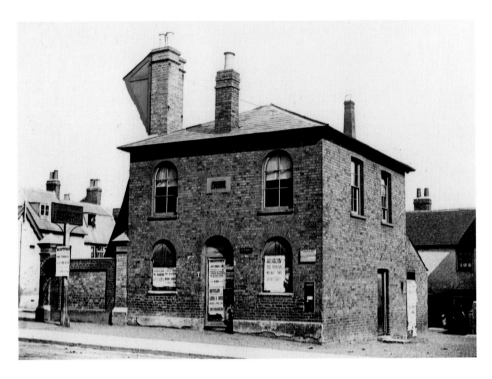

The Cage and Fire Station

Built in 1813 in Ferry Square, this 'cage' or 'lock up' is where drunks and other miscreants were confined before appearing before the magistrates. It was demolished in 1897 to make way for the Fire Station, designed by Brentford Urban District Council's architect and surveyor T. Nowell Parr. The Fire Station closed in 1965 and the premises are now a restaurant.

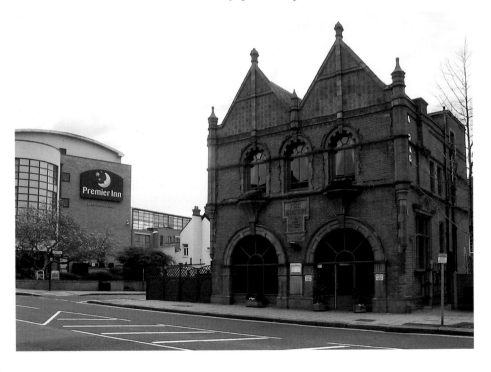

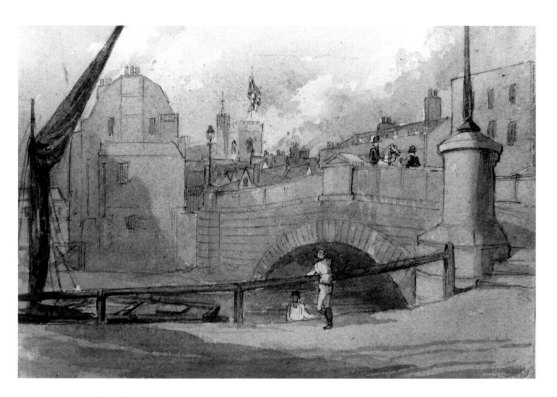

Brentford Bridge

The delicate watercolour of Brentford Bridge was painted some time after 1845 and shows the bridge which was put up in the 1820s. It replaced earlier wooden, brick and stone bridges. At the beginning of the twentieth century it was decided to widen the bridge and redo the upper section which is constructed of granite, concrete and iron. The old bridge still acts as the support and can be seen below the present bridge.

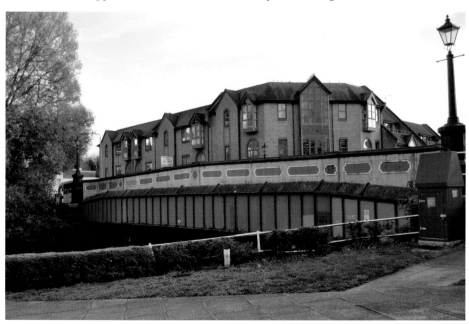

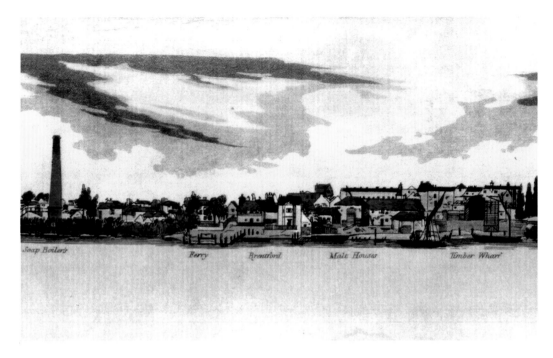

Soap Boilers Ferry Brentford Malt Houses Timber Wharf

Brentford Riverside

This section of Samuel Leigh's *Panorama of the Thames* shows Brentford from the river in about 1830. The ferry ceased to run in 1939 and, as the modern photograph shows, the malt houses and timber wharves have given way to offices, flats and restaurants.

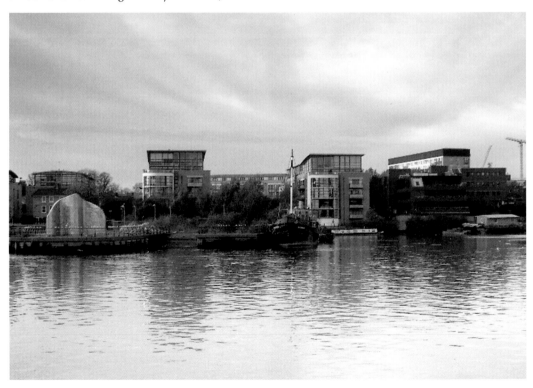

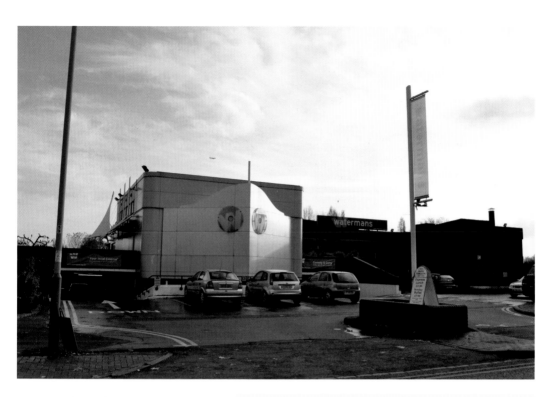

Royal Hotel

This gloomy looking building was built around 1828 by Sir Felix Booth, a prosperous City merchant who was elected one of the sheriffs of London and Middlesex. Booth also owned Brentford's Royal Brewery (see p 25) and a large distillery on the north side of the High Street (commemorated in Distillery Road). The distillery contained 300 oxen which were fattened up on the mashed grain remaining after the distilling process. The hotel was demolished in 1927 to make way for an extension to the gas works. On its site today is the Watermans Arts Centre which has a theatre, cinema, an art gallery, restaurant and bar. It was opened by Princess Alexandra in 1984.

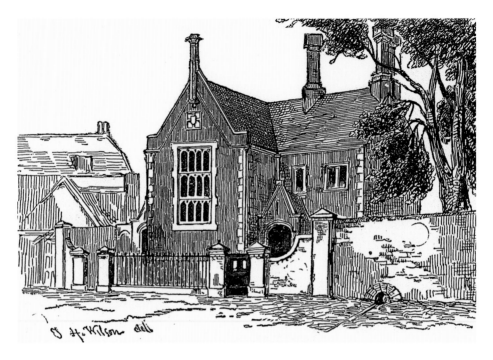

The Girls' School, Half Acre

This was the 'new and excellent school room' built in 1840 for the girls of St Lawrence's charity school. It was rebuilt in 1893 and functioned as a school until 1931 when Brentford Secondary Modern School in Boston Manor Road was opened. The 1893 building still remains and is now used as a day nursery.

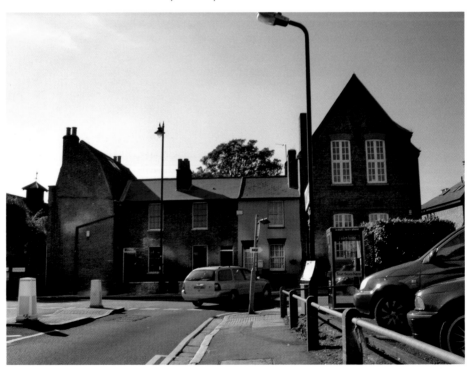

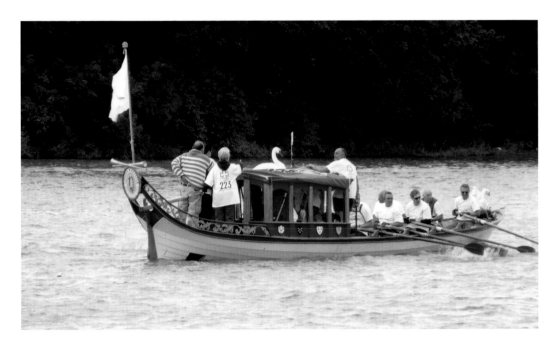

Swan Upping

The old picture is captioned 'Swan Upping on the Thames from Brentford Ait'. Swan Upping acts as an annual census of the swan population and a health check. Unmarked swans are caught, ringed, weighed and measured then released. Swan Upping still takes place but further upriver now. Spectators, however, can watch other events on the Thames like the 21-mile Great River Race. The modern photograph shows a competing boat approaching Kew Bridge during the race in 2010 – and includes a swan!

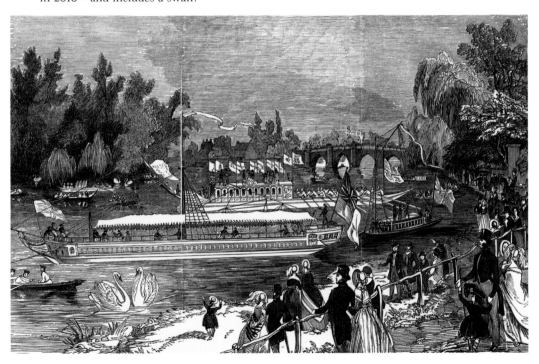

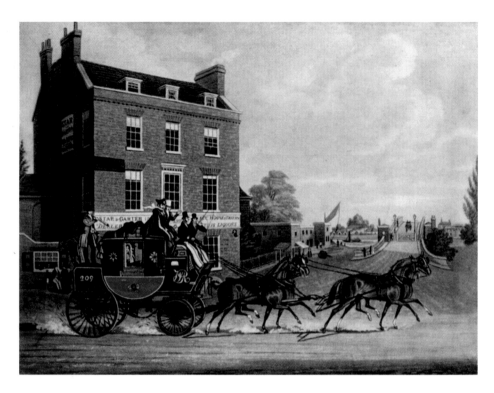

The Star and Garter

James Pollard's painting shows the Quicksilver Royal Mail coach passing the Star and Garter in 1825. Many important Brentford functions were held in this famous old pub, which was licensed from at least 1759. Last orders came in 1983 when the building was converted into offices, although its original façade was retained.

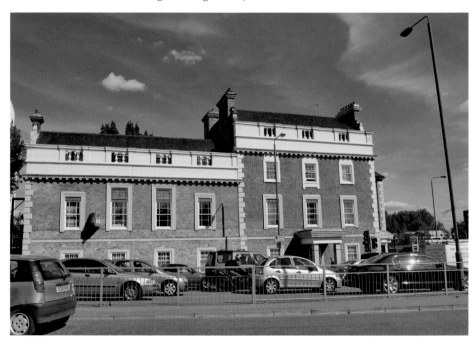

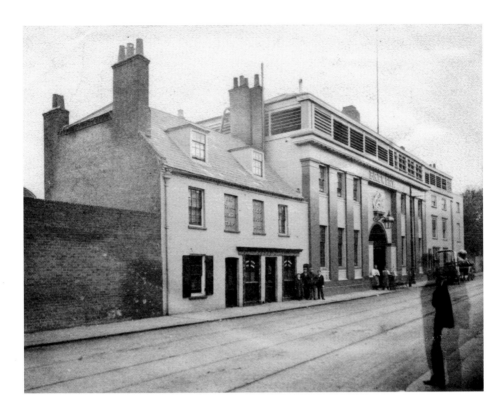

The Royal Brewery

A brewery was on this site from at least 1735. It was named the Royal Brewery by the future King William IV in 1829 in gratitude for its owner Sir Felix Booth's sponsorship of Captain James Ross's expedition to discover the north-west passage between the Atlantic and Pacific oceans. The brewery closed in 1923 and the building was demolished to make way for an extension to the gasworks. The leafy space of Watermans Park now covers the site.

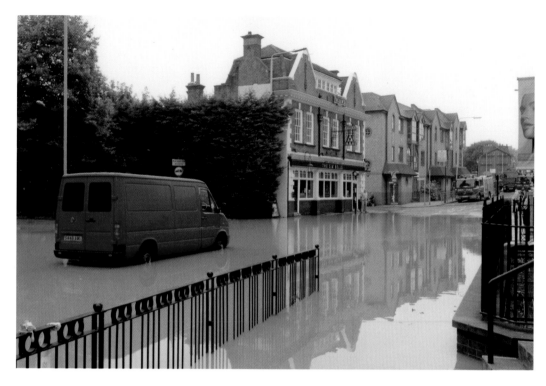

Floods

Low-lying Brentford was often flooded. The old picture shows vessels heaped against the bank of the canal off Syon Park during a particularly severe flood in 1841 when the River Brent burst its banks following a sudden thaw. Today, Brentford still seems prone to floods, not from the rivers, but from burst water mains. The modern photograph shows Brentford High Street under water in September 2010.

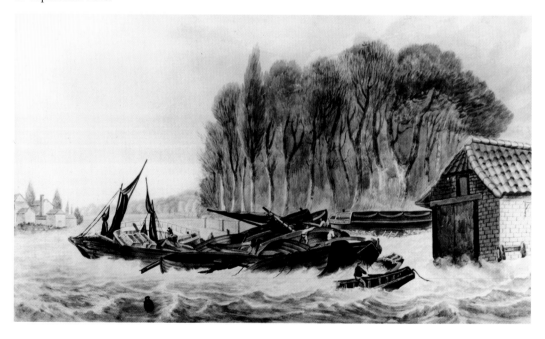

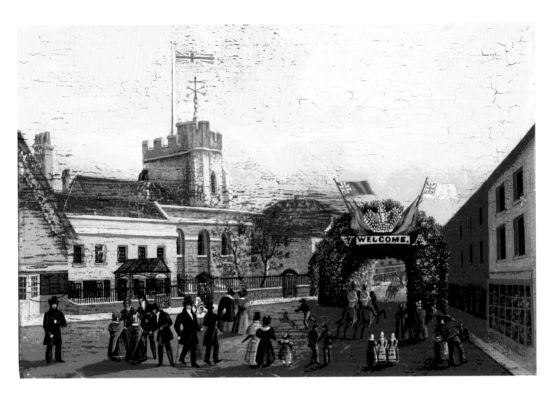

Arch for Queen Victoria

This arch was one of two put up in Brentford High Street to celebrate Queen Victoria's wedding day on 10 February 1840. The Queen and Prince Albert passed through Brentford on their way to their wedding breakfast at Windsor. Their visit was marked by peals from the bells of St Lawrence church, pubs and houses illuminated, and a dinner laid on for the local school children.

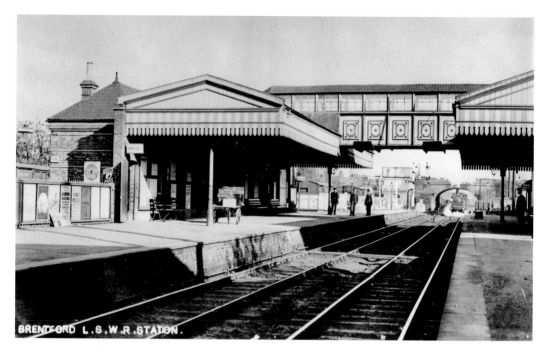

Brentford Station

The station was built in 1849 on the London & South Western Railway's loop line running initially between Isleworth and Barnes, and later from Hounslow to Waterloo. This is how the station platforms looked in 1910 and in 2010 respectively. The approaching train is coming from Waterloo.

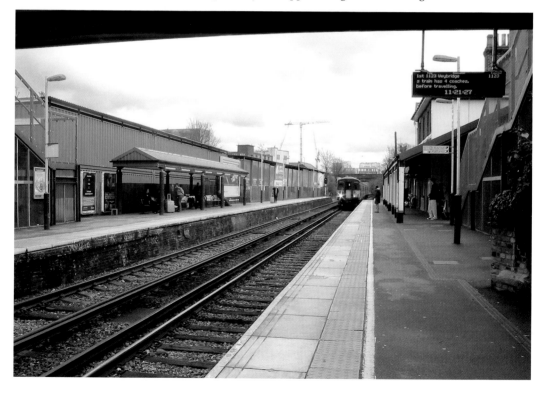

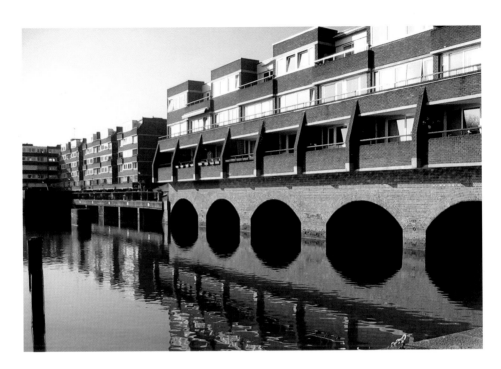

Brentford Dock

The Great Western Railway Company (Chief Engineer Isambard Kingdom Brunel) built its dock and railway at Brentford in 1859 so that goods from the West Country could be transferred onto barges for delivery to the London docks. Warehouses and other structures were put up. The Dock closed in 1964 and, in the 1970s, the Brentford Dock housing development was built by the Greater London Council. Some of the arches which supported the wharves were retained, as shown in the modern photograph.

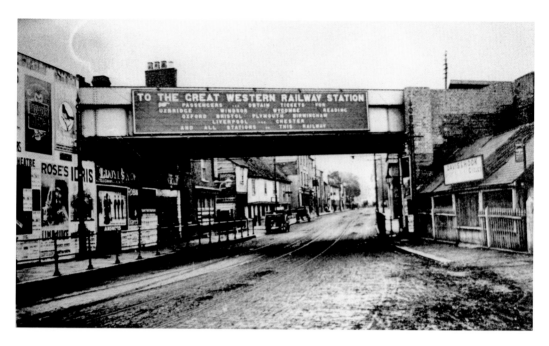

Great Western Railway Bridge

The Great Western Railway Company built a spur line to Brentford from Southall in 1859 with its own station in London Road so that goods from the west could be transported by train to Brentford Dock. The old photograph shows the railway bridge which ran across London Road. The bridge was demolished in 1966 but, as the modern photograph shows, its supports are still visible.

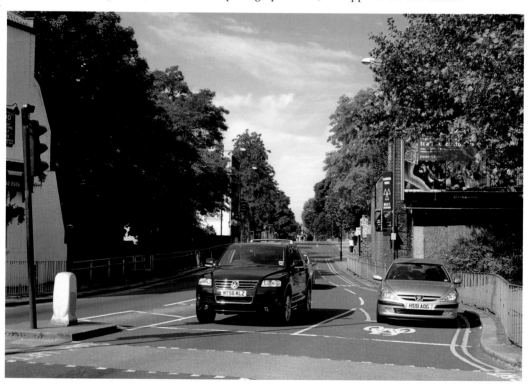

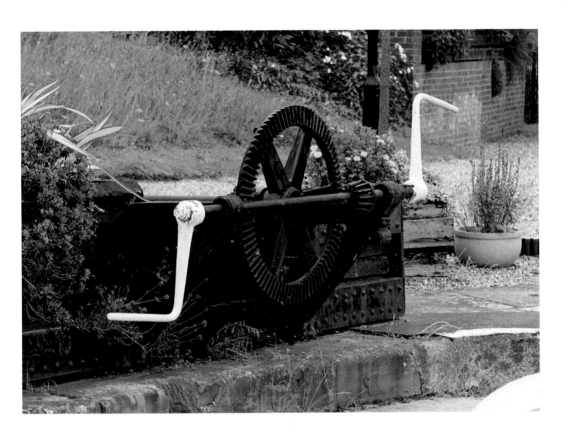

Opening the Dock Gate
James William Penny and William Knock operating the gate to Brentford Dock. It was opened for a couple of hours either side of high tide each day. When Brentford Dock closed in 1964, these chaps lost their jobs after a combined ninety-three years of service at the Dock. The windlass that opened the gate still survives but is not intact and has found a new use as a planter.

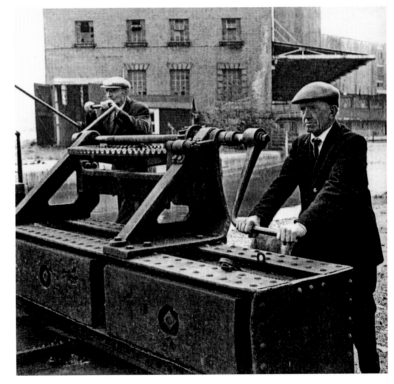

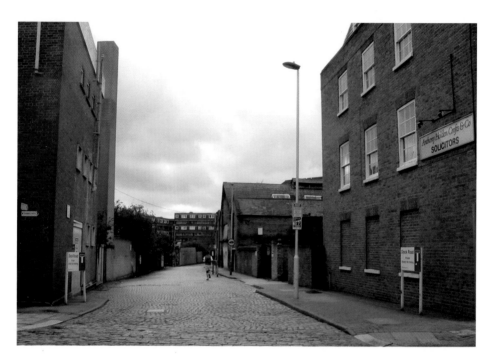

Entrance to Brentford Dock

Dock Road was the vehicular and pedestrian entrance to Brentford Dock. The Dock warehouses can be seen in the distance on the 1964 photograph and their replacement, the Brentford Dock housing development, in the modern photograph. Dock Road still retains its fanned paving setts. The old building on the right, a hay and straw merchants from 1871 to 1912, was demolished in November 2010, a few months after the photograph was taken.

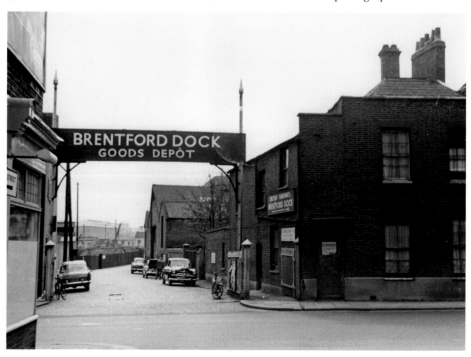

The Waterworks Tower

The handsome brick tower at the Kew
Bridge Steam Museum is a Brentford
landmark, but the original standpipe
tower of the Grand Junction Waterworks
was the flimsy lattice structure shown in
the old photograph. The present tower
197ft (60m) high replaced it in 1867. The
standpipe tower was a safety device to
guard against damage to the pumping
engine should mains pressure be lost
by the breaking of the main The Grand
Junction Waterworks, pumping water
from the Thames, opened at Kew Bridge
in 1837. Trees obscure the same view
today so the modern photograph shows
the tower from Kew Bridge Road.

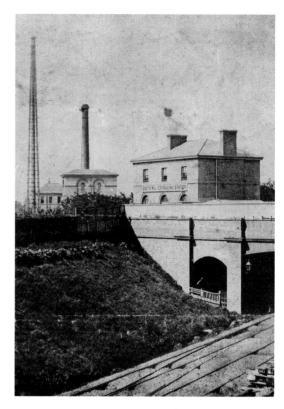

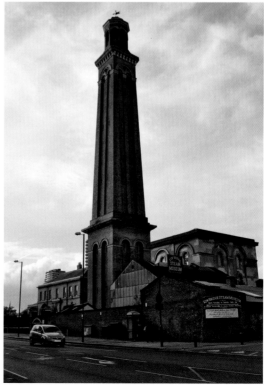

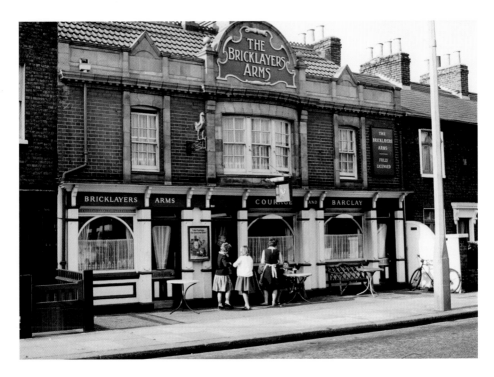

Bricklayer's Arms

This pub, operating since 1853, was closed and turned into three residential units in 2009 – a sad sign of the times. Its loss with be mourned particularly by fans of Robert Rankin's fantasy tales, set in Brentford, in which the pub was immortalised as the Flying Swan.

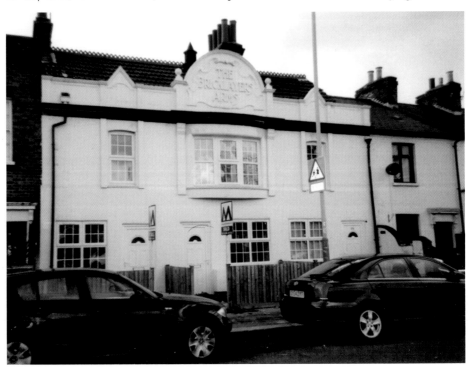

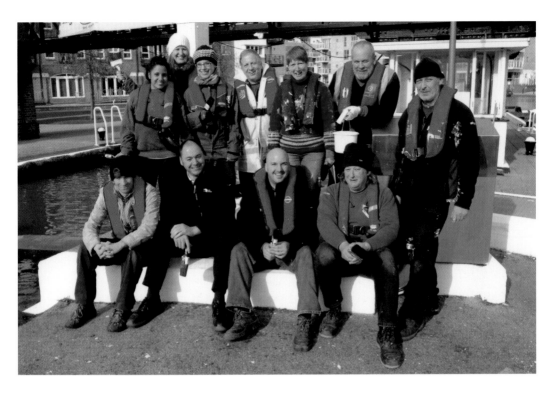

The Gauging Locks

These locks replaced an earlier lock which was washed away by floods in 1898. 'Gauging' was the process of measuring the weight of a boat's cargo to determine the amount of toll to be paid to use the canal. The modern photograph shows volunteers sprucing up the gauging lock in 2010.

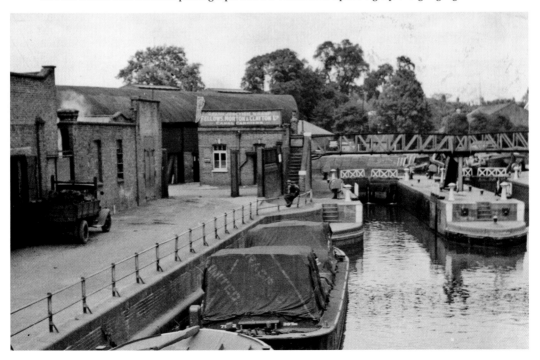

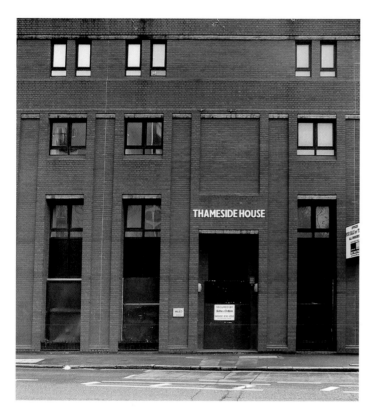

The Police Station

The old photograph shows Brentford's second police station opened in 1870. The first station, on the corner of the High Street and Town Meadow (now a solicitor's office), opened in 1829 when Brentford became part of the Metropolitan Police. The second station operated until 1966 when a new police station was built in the Half Acre. The building was demolished in 1969 and the modern photograph shows the office block called Thameside House which was put up in its place. This is now one of the many empty properties that disfigure the face of Brentford in 2010.

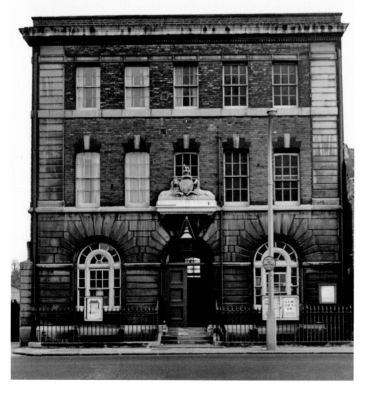

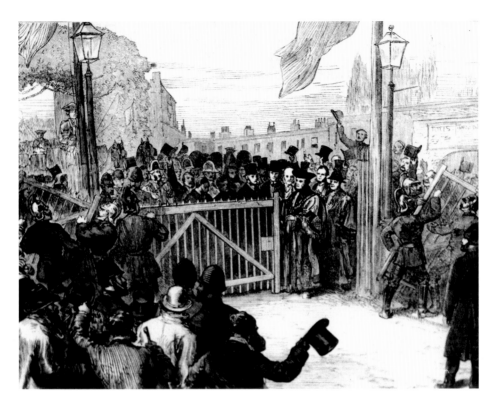

Kew Bridge Free from Tolls

People had to pay to cross Kew Bridge until 1873. This picture shows that there was great rejoicing on the 8 February 1873, the day the tollgates were removed. They were placed on a brewer's dray and paraded around Kew and Brentford. Congestion of a different kind is commonplace at the entrance to Kew Bridge in 2010.

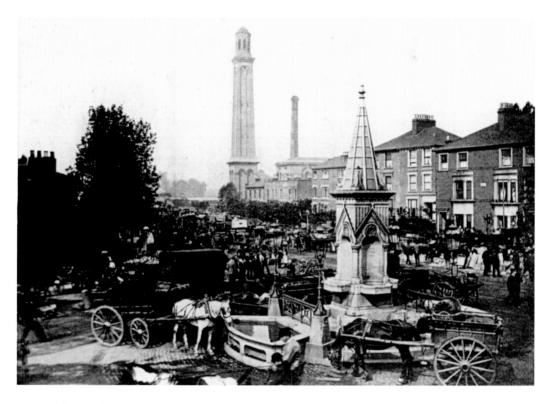

Kew Bridge Market

An informal market selling fruit and vegetables grew up near Kew Bridge around the large fountain which was installed in 1877. The old photograph shows this market in 1892. Many of the buildings remain in 2010, but not the fountain. It was removed to the Western International Market in North Hyde when the Brentford Market was transferred there in 1974.

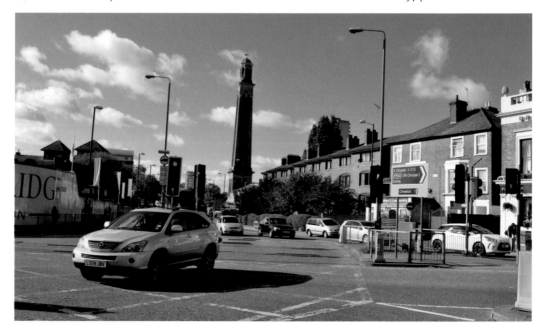

Brentford Theatre

Jam maker Thomas Beach, who owned a factory off the Ealing Road (see p 80), opened a theatre in Walnut Tree Road, ostensibly as a philanthropic gesture to provide entertainment for his workers, but perhaps really to discourage them from spending too much time in Brentford's many pubs. The old photograph, taken in about 1886 shows a sign for the theatre on the Bull pub which stood at the junction of Pottery Road and the High Street. This section of Brentford High Street now forms part of the Haverfield Estate which was built in the 1970s and is set further back from the road.

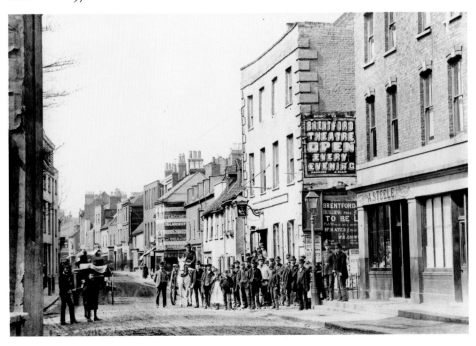

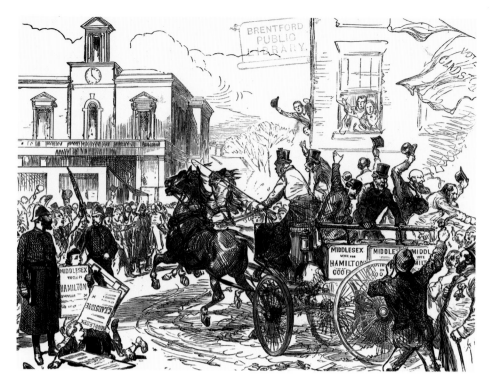

The Magistrates' Court

Voting at the Parliamentary elections of 1880. By this date the hustings had moved from the Butts to stand outside this building which had been erected in 1850, and which became the Magistrates' Court in 1891. In 1929 a new front extension was added to the building. The modern photograph shows an event to celebrate St George's Day in April 2010 taking place outside the Court.

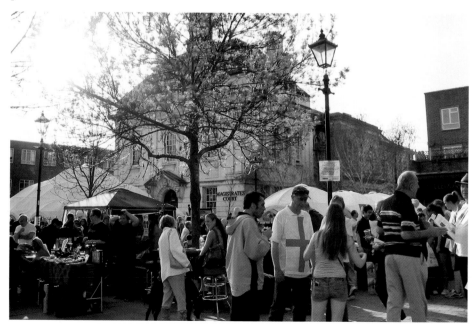

West End of Brentford High Street

This stretch of Brentford High Street has been redeveloped completely since the 1890s when the old photograph was taken; even the Six Bells pub, visible in both pictures, was rebuilt in 1904. The only recognisable feature is the fifteenth century tower of St Lawrence's Church – the oldest structure in Brentford.

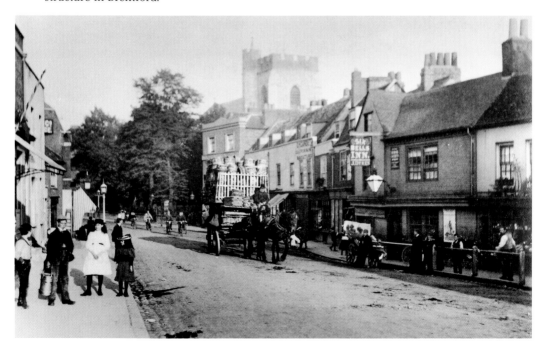

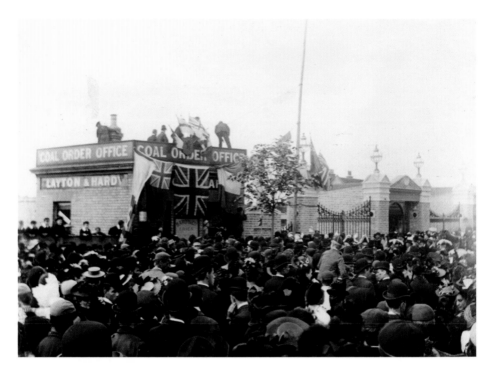

Gates to Brentford Market

The old picture shows the opening of Brentford's wholesale fruit, flower and vegetable market in 1893. Behind the crowds are the market's original gates some of which were removed when the market was extended in 1905. The new photograph shows one of these gates, now the gate at the Staveley Road entrance to Chiswick House.

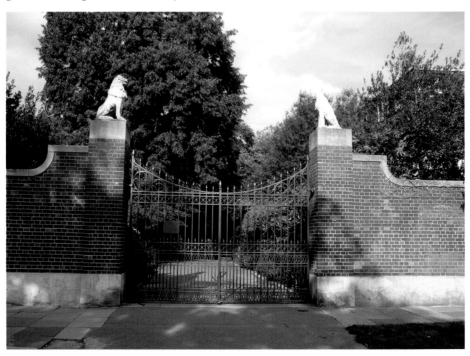

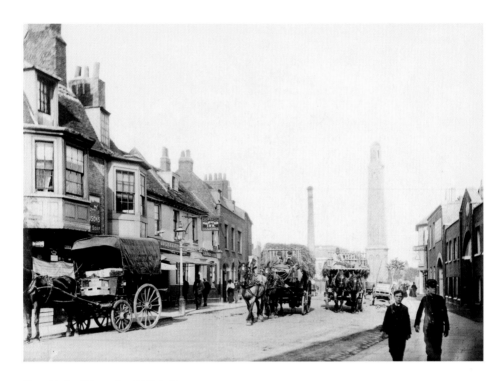

East End of Brentford High Street

This is how the east end of the High Street looked at the end of the nineteenth century with the distinctive tower of the Waterworks (now the Kew Bridge Steam Museum) visible in both pictures. The building on the left in the modern photograph is the new premises of the Musical Museum, while the petrol station marks the site of the Salutation pub at 401 Brentford High Street.

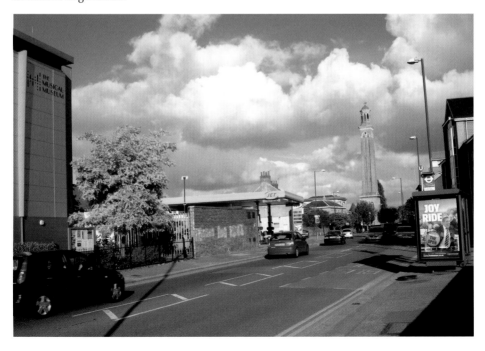

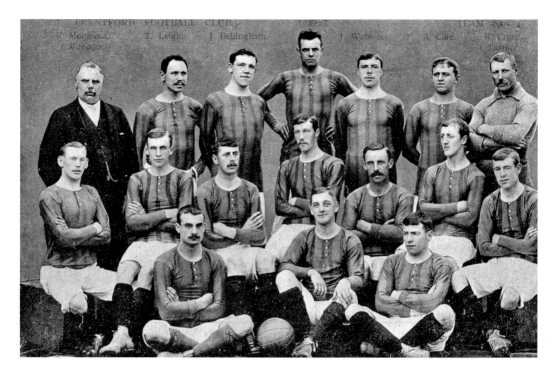

Brentford Football Club

The BFC team for the 1903/4 season when they were playing on rented fields and using the Griffin pub as a clubhouse and changing rooms. Although the decision to form a football team for Brentford was taken in 1889 it wasn't until 1904 that the club moved to its present ground, Griffin Park, named in honour of the pub. The modern photograph shows the 2010/11 squad.

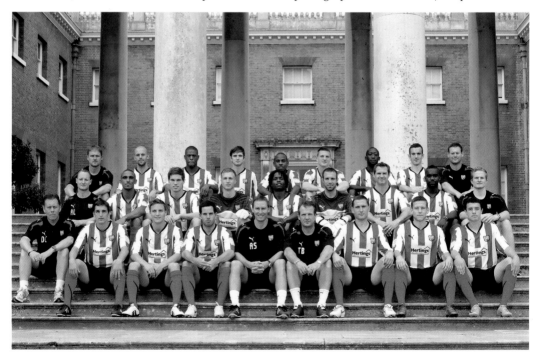

The Vestry Hall

This magnificent building on the corner of Half Acre and St Paul's Road was opened in 1900. It was designed by Brentford Urban District Council's able architect T. Nowell Parr and could seat 680 people. It was used for various functions including sittings of the county court until the present County Court was built in 1963. The Vestry Hall was demolished in that year to make way for the police station and section house, shown in the modern photograph.

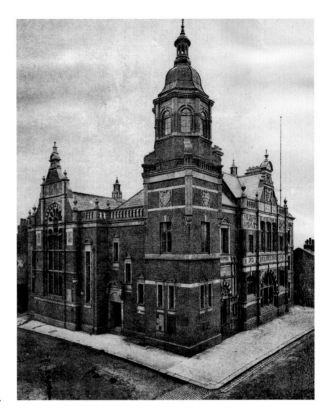

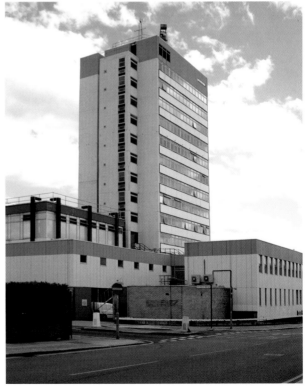

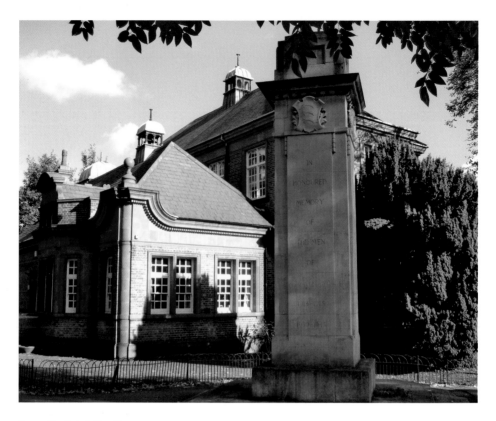

Brentford Public Library

The library was built with a grant from the American philanthropist Andrew Carnegie who opened it himself in 1904. The building on its left was Clifden House (demolished in 1953), the headquarters of the Brentford Local Board. Shrubbery blocks the same view today but the modern photograph shows the War Memorial in the Garden of Remembrance.

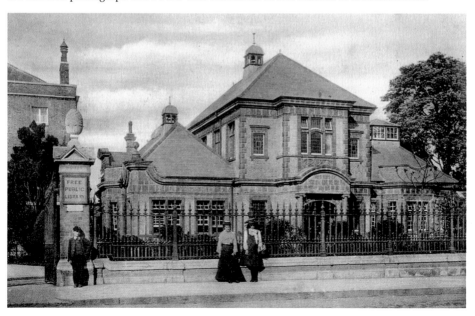

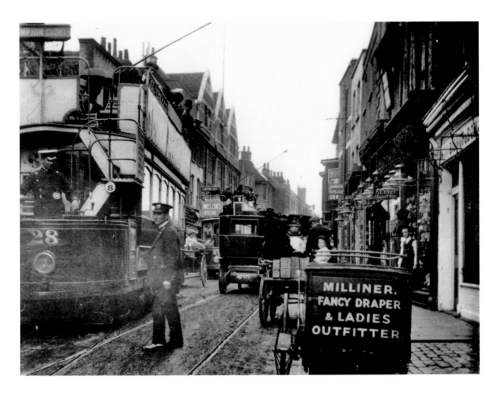

Busy Brentford High Street

For centuries people had been complaining that Brentford High Street was too narrow, too crowded and too dirty. The old photograph shows the High Street in the early twentieth century, after the introduction of trams in 1901. These restricted the roadway even more. It was widened in a piecemeal fashion during the twentieth century but as the modern photograph shows is still busy.

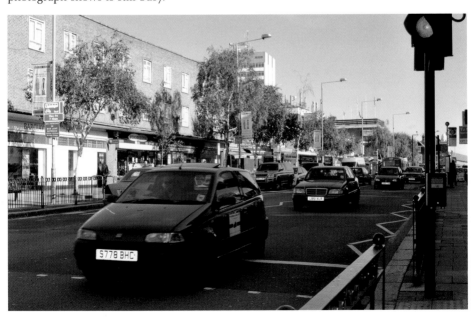

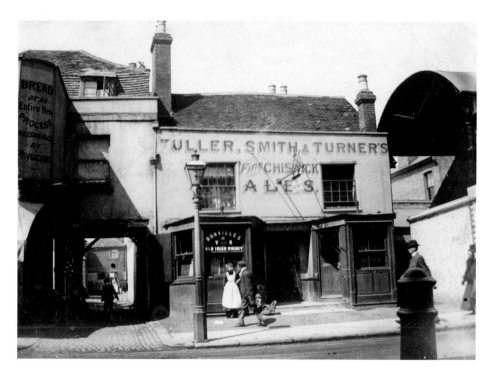

The Prince of Wales

This pub pictured in *c.* 1902 was at 346 Brentford High Street and was known for the beautiful frescoes of animals which adorned its walls. Its site is now part of the Haverfield Estate, set back from the road, which was built in the 1970s.

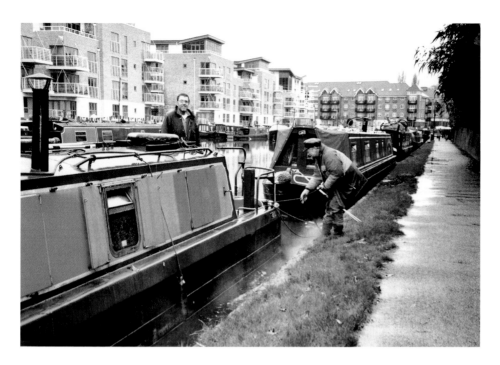

Narrow Boats on the Canal

The old photograph shows boat people meeting up on the canal at Brentford in the 1900s. The 'narrow boats' were the workhorses of the canal and doubled up as homes for the families who operated them. The two chaps in the 2010 photograph are setting out for a jaunt on their floating home.

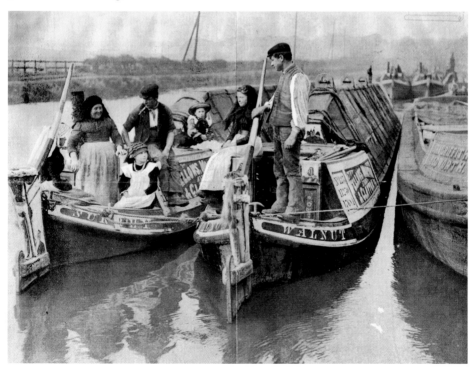

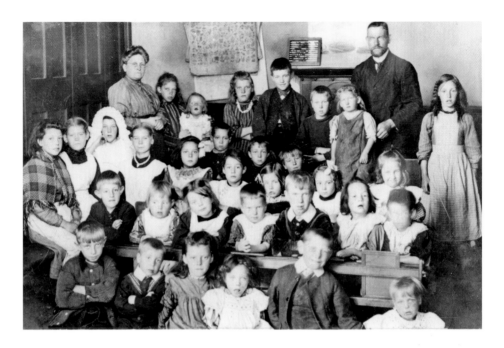

The Boatmen's Institute

An attempt to offer some education to the peripatetic children who travelled on the canal boats was made in 1904 at the Boatmen's Institute. This was run by the London City Mission and functioned also as a community centre, church and maternity hospital for the travelling barge and boat people. It closed in 1978 and is now a private house. The old photograph shows the boat children and their teachers, the modern photograph the building itself.

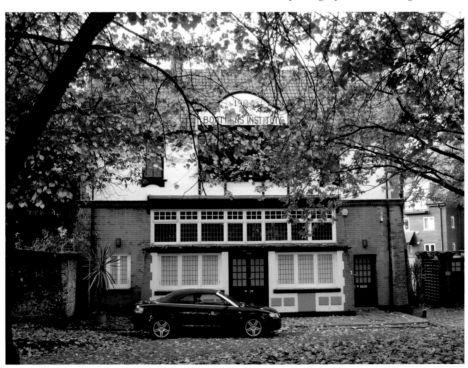

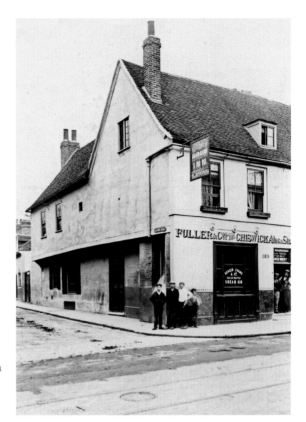

The Drum

This pub, pictured in about 1900, gave its name to Drum Lane, which was the previous name of the lower part of Ealing Road. Licensed by at least 1722, the pub was demolished in 1921 when Ealing Road was widened. Today refreshments are available from fast food restaurant MacDonald's, the car park of which marks the site of the pub.

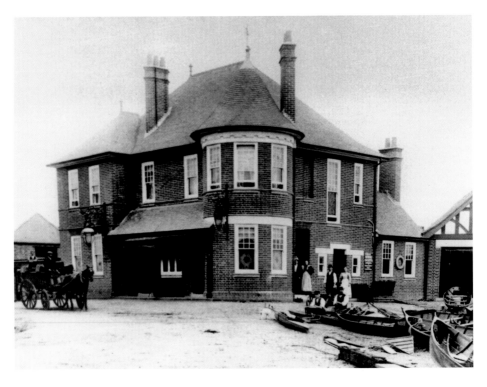

The Ferry Hotel

There was a pub by the Brentford ferry from time immemorial. The building in the old photograph was put up in 1880 and licensed as the Bunch of Grapes. The licence was surrendered in 1922 and the building was used as offices until it was demolished in 1983. San Marco, an Italian restaurant, is now on its site.

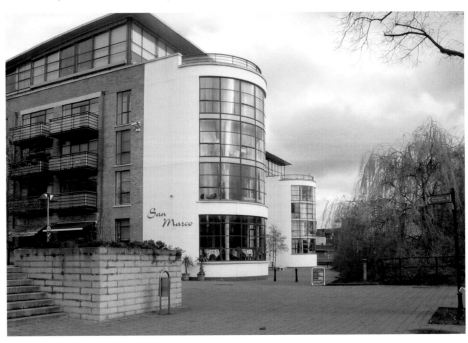

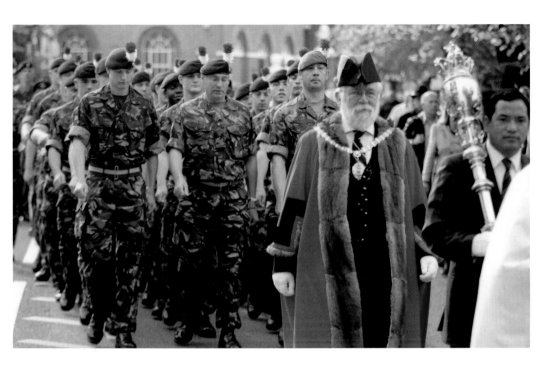

King Edward Driving over Brentford Bridge

The old photograph shows King Edward VII being driven over Brentford Bridge in about 1903. We couldn't rustle up a king or queen for the modern photograph but, instead, show the Mayor of the London Borough of Hounslow leading a procession to rededicate the War Memorial that stood outside St Lawrence's Church and which was moved to the Remembrance Garden outside Brentford Library in 2009.

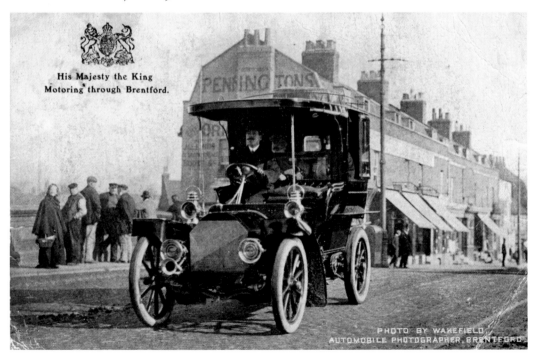

His Majesty the King
Motoring through Brentford.

PHOTO BY WAKEFIELD
AUTOMOBILE PHOTOGRAPHER, BRENTFORD

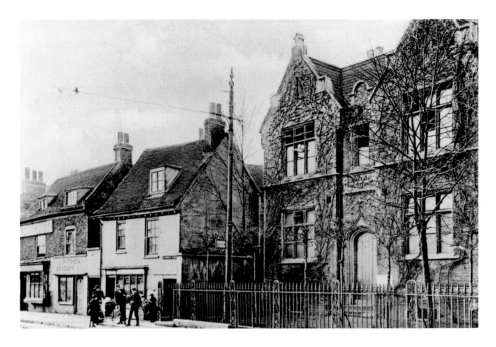

Rothschild School

This 1901 photograph shows Brentford British School which opened in 1834. It was renamed the Rothschild School in 1906 in gratitude for the great generosity of the Rothschild family of Gunnersbury Park. It closed in 1930 and the building was demolished in 1936 and replaced by Alexandra House, now a Grade II listed building, which is used as a community centre.

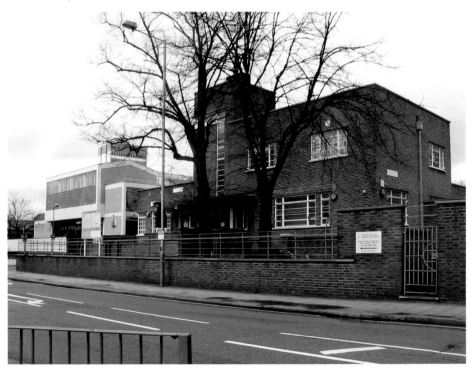

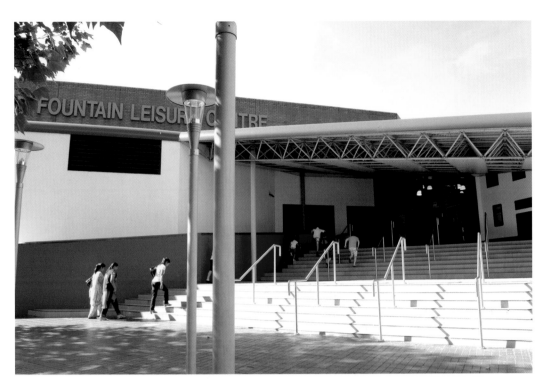

Fruit and Vegetable Market

The old photograph shows the entrance to Brentford's famous wholesale fruit and vegetable market. The open market, shown on p 42, was so successful that an enlarged covered market building was opened in 1906. In its heyday the market covered 11 acres, almost all the land between the present Kew Bridge Station and the Chiswick Roundabout on the west side of Chiswick High Road. The market closed in 1974 and the building was demolished in 1982. Offices and other buildings, including the Fountain Leisure Centre, were built on its site. The modern photograph shows the entrance to the Fountain Leisure Centre.

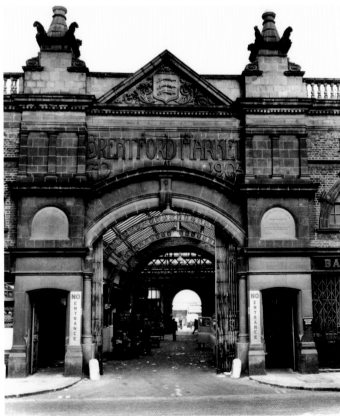

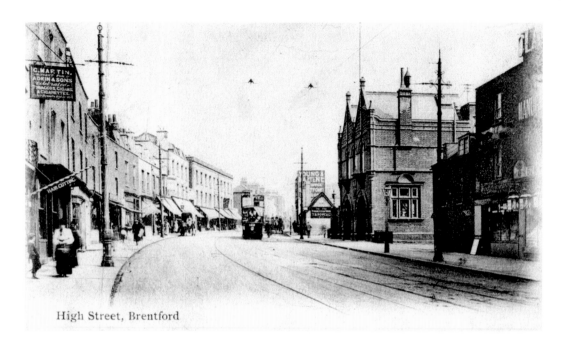

High Street, Brentford

Brentford High Street by the Fire Station
Views of this section of Brentford High Street in about 1910 and 2010. Apart from the Fire Station (now a restaurant) most of the other buildings have gone but the High Street still retains its distinctive curve.

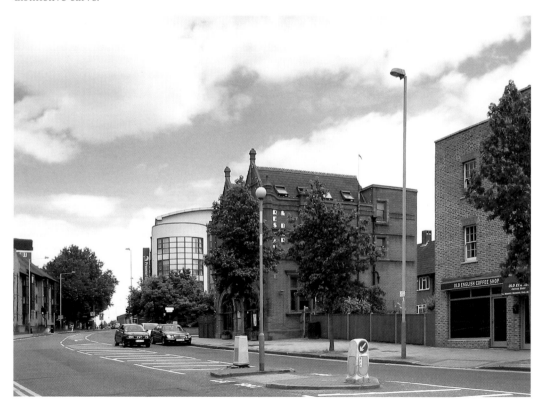

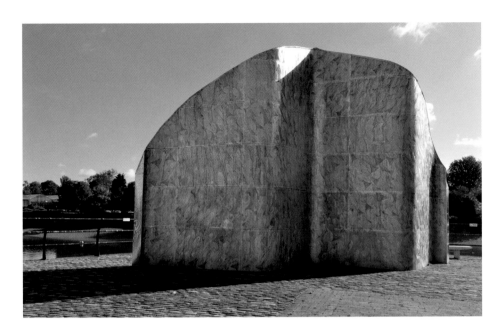

Opening of the Monument

The Duke of Northumberland unveiling the Brentford Monument in 1909. It was made from granite cylinders which had previously supported the lights on Brentford Bridge (see p 19). For details of the inscriptions on the Monument see p 89. On the Monument's original site today is a sculpture called 'Liquidity', created by Simon Packard. Made of electro-plate stainless steel, it displays images of local wildlife.

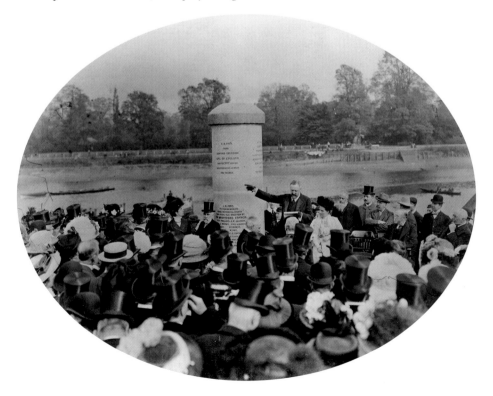

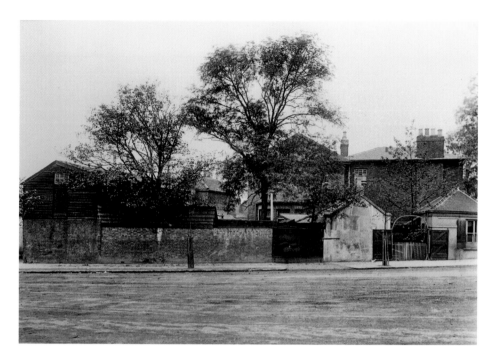

Thomas Layton's House

This house, on the corner of Kew Bridge and Kew Bridge Road, was the home of Thomas Layton (1819-1911), a prominent local figure and a prolific collector of antiquities, which overflowed into thirty sheds in his garden. After an office block built on the site was demolished, it lay empty for eighteen years. The modern photograph shows the site in 2010 when it was taken over by a group of eco-warriors. They were turfed out and the site is now being developed.

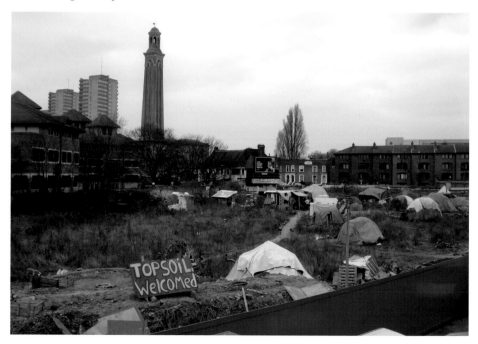

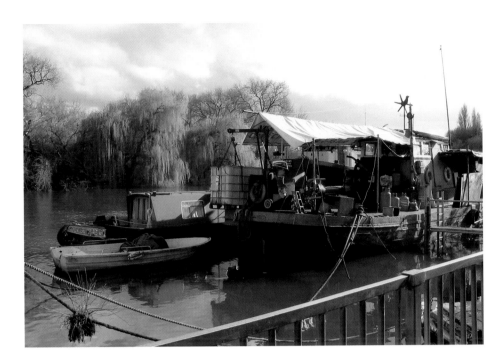

Beating the Bounds

The people on the boat in the 1911 photograph are part of a procession which took place every year until the 1920s to remind locals of the boundaries of their particular parish and to impress them on the young. The willow wands they are holding were used to beat the boundary stones. Today the boats along the riverbank by Watermans Park tend to be stationary and are used as dwellings.

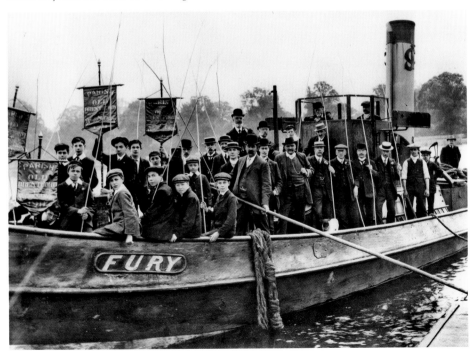

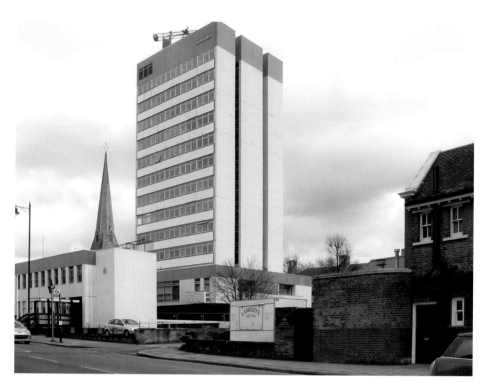

Queen's Cinema
This cinema in Half Acre, next door to the Beehive pub, opened in 1912 with seating for 600 people. It closed in 1957 and the building was demolished in 1963 to make way for the new police station and Section House. Langley's shellfish stall has been trading from the pub car park for many years.

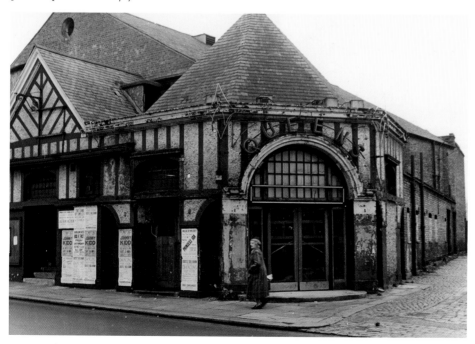

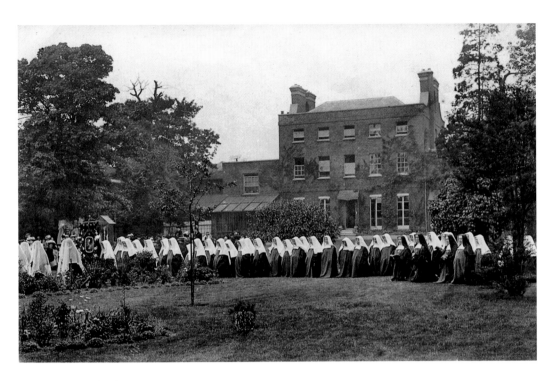

Convent in the Butts

A Corpus Christi Procession outside St Mary's Convent in the Butts sometime before 1913. The white veils indicate that some of these nuns are novices. The convent, opened in 1880, is one of the houses belonging to a Catholic Order of Religious Sisters the Poor Servants of the Mother of God. The modern photograph shows additions to the original building; the tall block on the left was put up 1913-1914; the buildings on the extreme left in 2001.

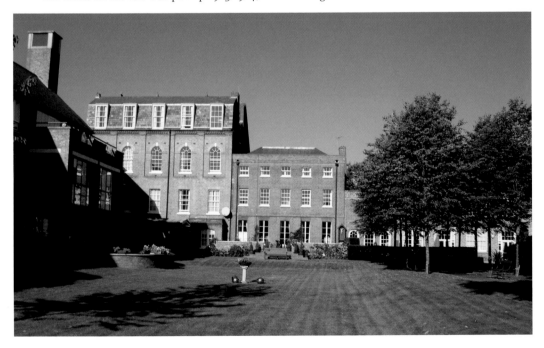

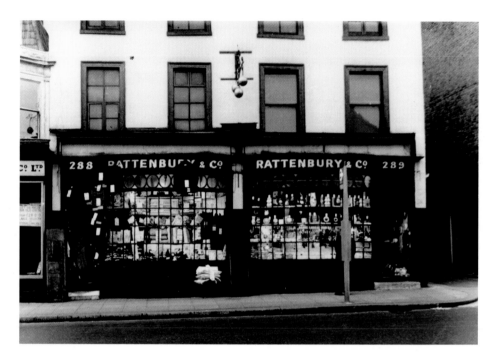

Rattenbury's

This attractive bow-fronted shop at 288/9 Brentford High Street was a jeweller's and a pawnbroker's, run by the Rattenbury family until 1957. The shop closed in 1968 and the building was demolished. Its façade, though, was taken to the Museum of London and put on display. The block of flats known as Watermans Court was built on the site in the early 1990s.

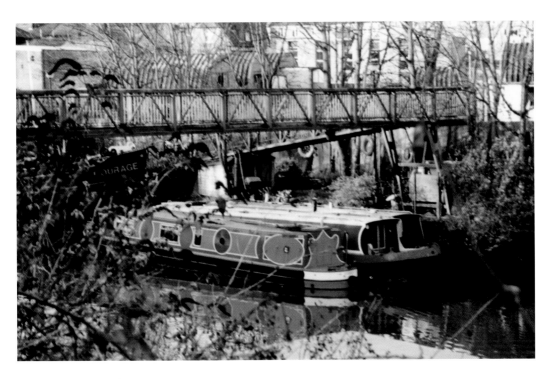

Turnover Bridge

The old picture shows the bridge over the canal at Brentford. The bridge is curved to enable the horses which pulled the boats to cross the canal. The modern photograph shows the bridge's replacement, the footbridge leading to Brentford Dock.

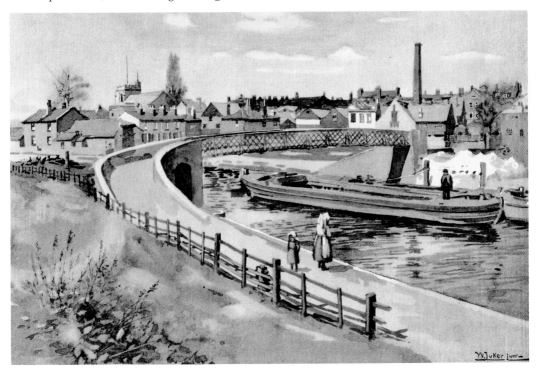

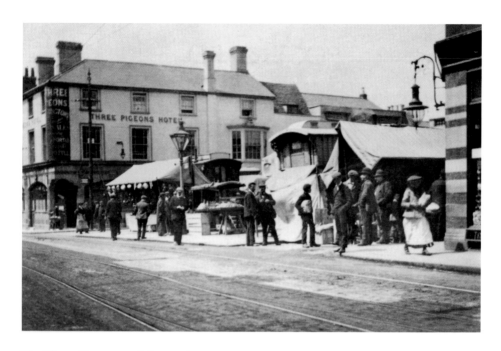

The Three Pigeons and the Market

The Three Pigeons was Brentford's premier pub, reputedly visited by William Shakespeare and Ben Jonson. A pub was on this site from at least 1436 when it was known as the Crown. Brentford's thriving market can be seen on the right of the picture which was taken in about 1905. The Three Pigeons closed in 1915 and the market in 1933. The building called the Market Building with a tile shop at street level now occupies the site of the pub.

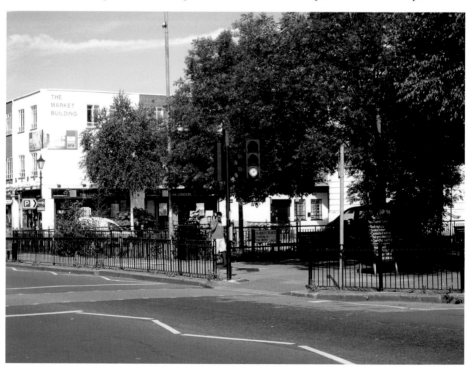

Brentford Fair

An annual six day fair was established in Brentford in 1306. The fair ran off and on until 1932 and gained a reputation for noise and vulgarity. The 1905 photograph shows the living wagons of the showmen who operated the fair's side shows parked in the Butts, which, as can be seen in the modern picture, is now a more peaceful place.

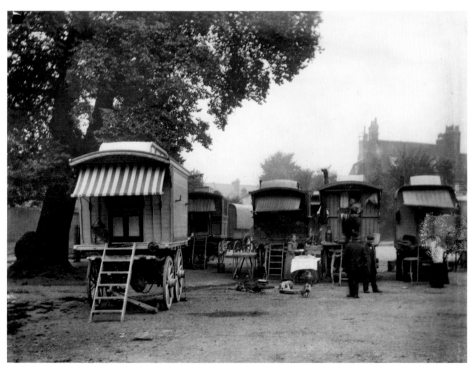

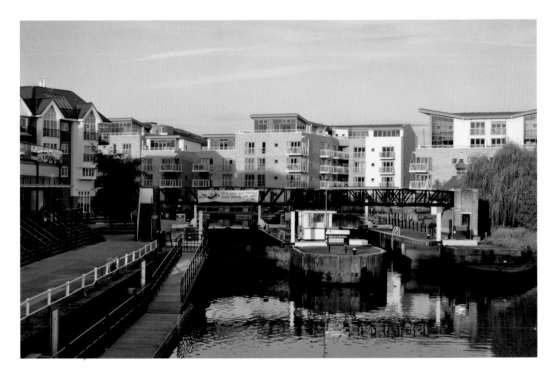

Canal and Toll House

The view from Brentford Bridge looking north towards the canal and gauging lock. The small building with the steeply pitched roof in the old photograph is the Toll House, built in 1911, where a clerk sat to collect tolls from boats using the canal. The Toll House is still there but obscured by the large willow tree in the modern photograph. A modern housing development has grown up around the lock.

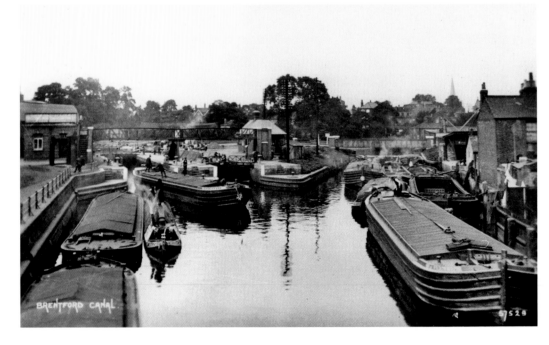

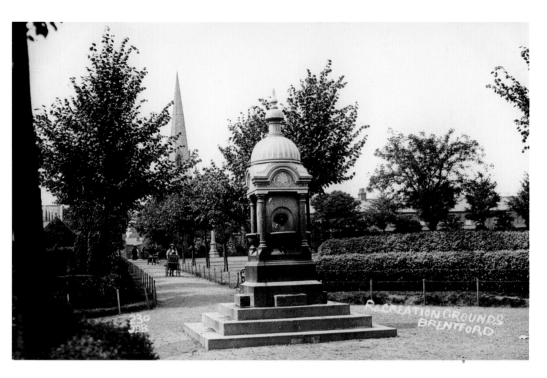

St Paul's Recreation Ground

A 1915 postcard of the fountain in St Paul's Recreation Ground. The fountain was installed in 1889 to commemorate Queen Victoria's Golden Jubilee of 1887. The modern photograph shows children from St Paul's School on a sponsored dinosaur walk in the Recreation Ground in 2010.

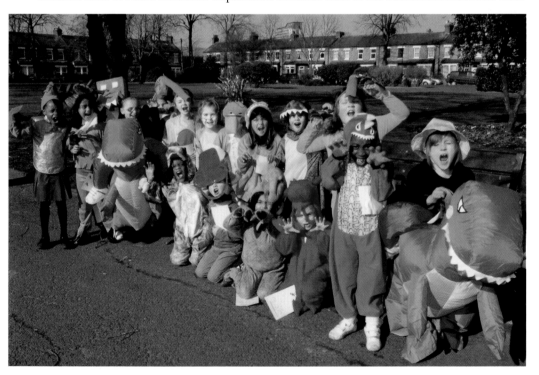

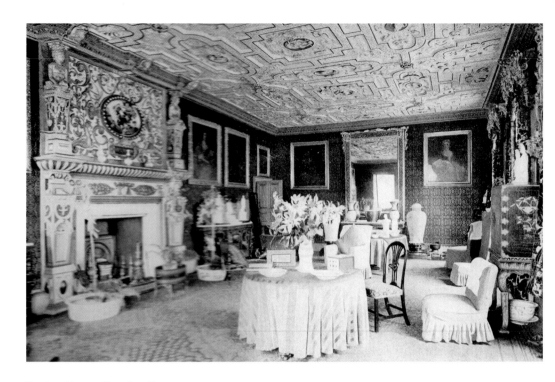

Boston House Drawing Room

This is the state drawing room of Boston Manor House in 1918. The house was sold to Brentford Urban District Council in 1923, but without the contents which had been sold by auction. A major restoration took place in 1963 with the purchase of furniture of the period and gold flock wallpaper specially made in France. The house was reopened by the Queen Mother in 1963.

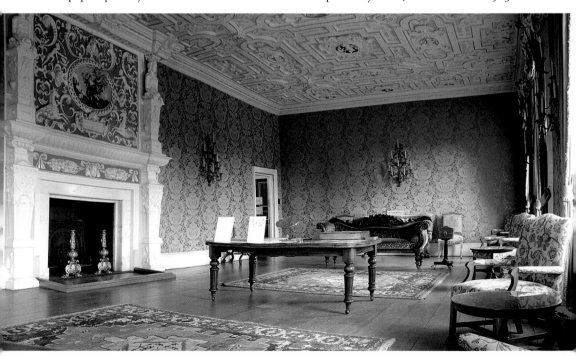

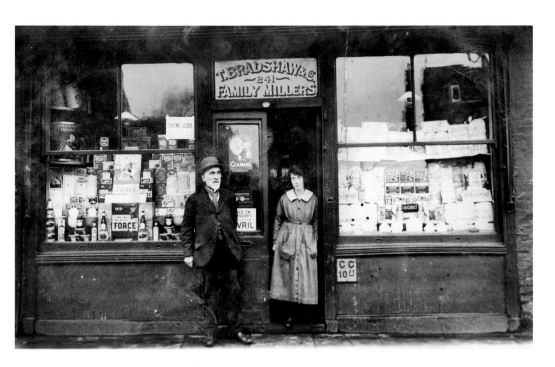

Bradshaw's Shop

This shop was at 241 Brentford High Street. The Bradshaw family were running it from 1926. People still buy their bread and other provisions at No. 241 since the address has been now absorbed into the supermarket currently known as Morrisons.

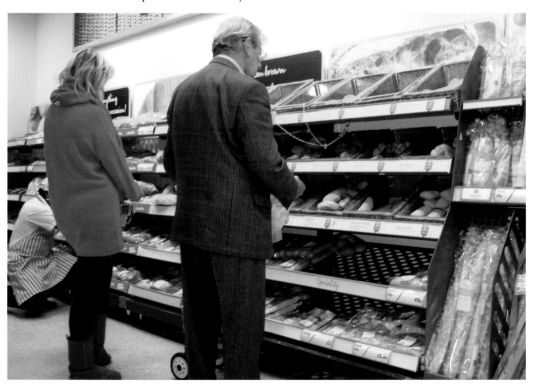

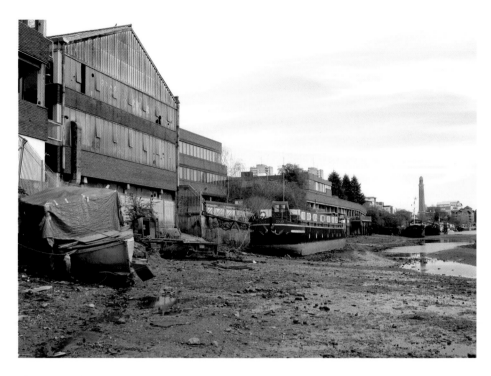

The Gasworks

Brentford has the dubious distinction of being one of the first places in the world where a gas works was built in 1820. At its greatest extent the gasworks stretched for a quarter of a mile along both sides of Brentford High Street and along the riverside. The gasworks closed in 1963 and Watermans Park, along with offices and flats now occupy its site.

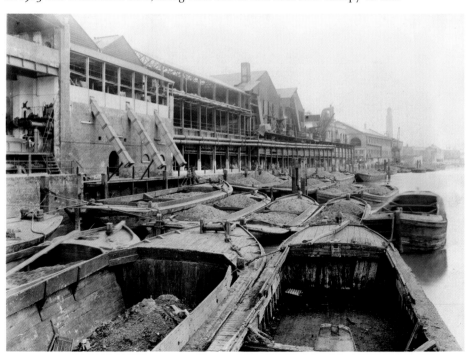

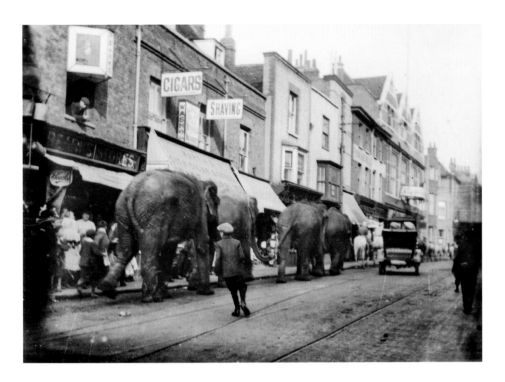

Elephants in Brentford High Street

From Roman times onwards Brentford High Street was the main artery to the west of England so all sorts of people, animals and vehicles must have tramped or driven along it. We don't know why the elephants in the old photograph are there, or when. They were probably something to do with the annual Brentford Fair which took place from 1306 to 1932.

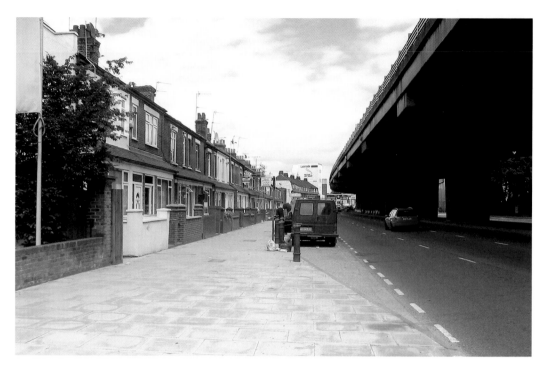

Adelaide Road

Adelaide Road looking east towards Chiswick. The houses on the left are still there, but those on the right were demolished in about 1924 to build the Great West Road (now the A4). Adelaide Road is now dominated by the elevated section of the M4.

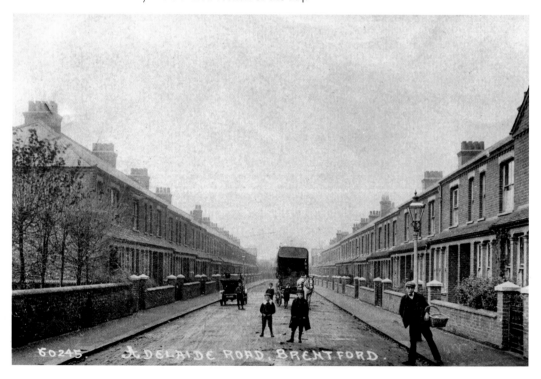

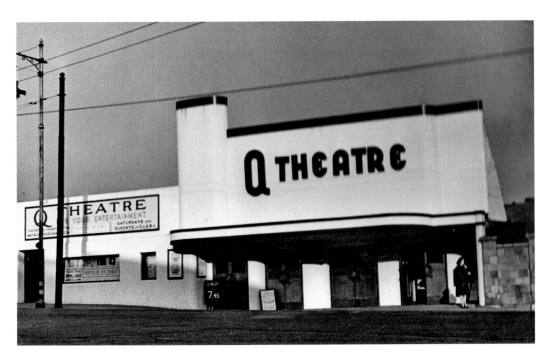

The Q Theatre
This famous little theatre was opened in 1924 and staged many plays that went on to become West End hits, and it was where many famous stars such as Dirk Bogarde, Joan Collins and Anthony Quayle first trod the boards. The theatre closed in 1956. Now on the site is Rivers House – flats converted from the former offices of the Ralph M. Parsons Group.

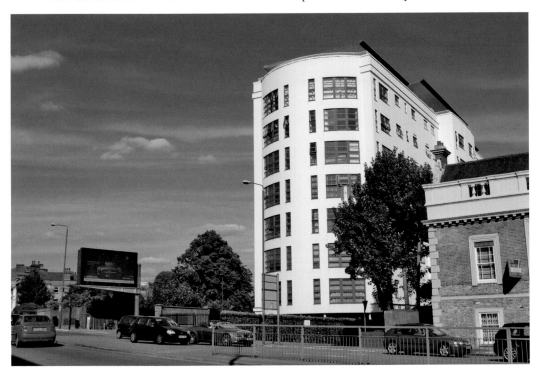

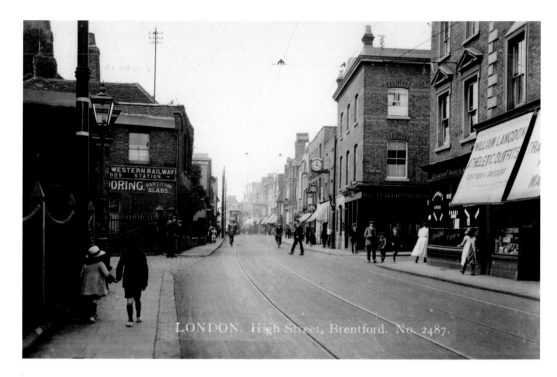

LONDON. High Street, Brentford. No. 2487.

Brentford High Street by Dock Road

The 1920s picture shows Dock Road on the left and St Paul's Road on the right with the Feathers pub on the corner. The pub was closed in the 1960s and the building demolished in the early 1990s to make way for the supermarket now known as Morrisons. The southern section of St Paul's Road lies beneath the supermarket's car park.

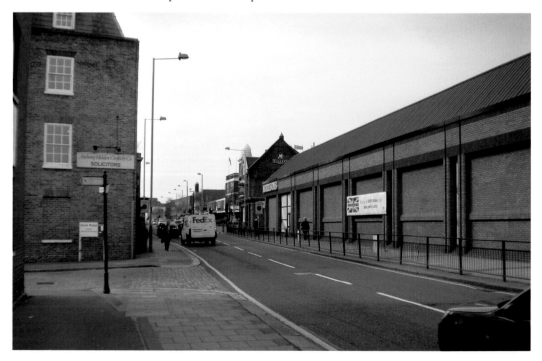

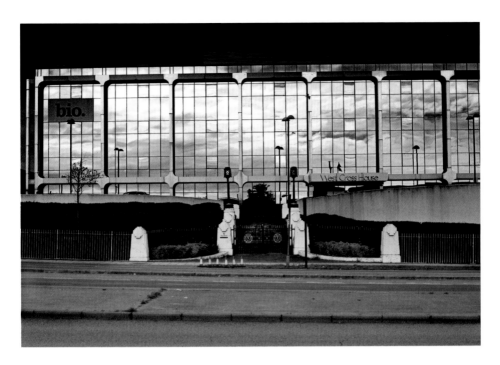

Firestone

The old photograph shows the factory built in 1928 for the Firestone Tyre and Rubber Company. It was considered to be one of the finest of the art deco factories in the Great West Road, but was wantonly demolished over the August bank holiday weekend in 1980, just days before it was due to be designated as a listed building. However, the pillars, gates, railings and steps remain and are shown in the modern photograph.

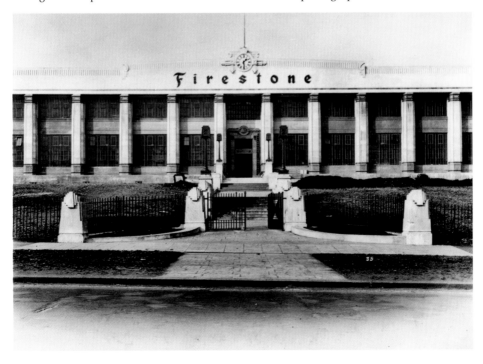

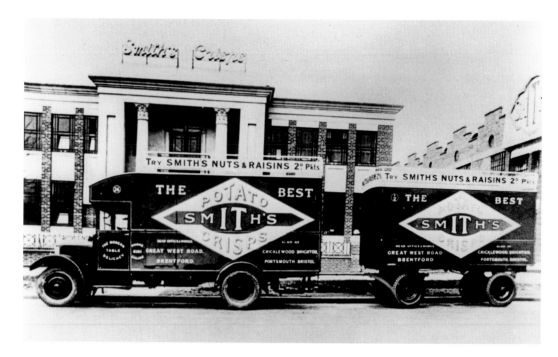

Smith's Crisps

One of many art deco factories on the Great West Road, Smith's Crisps factory opened in 1930. Smith's was acquired by the American General Mills Company and the Brentford factory closed in 1970, the building was demolished in 1988. It has been replaced by a new building now occupied by technology firm EMC2.

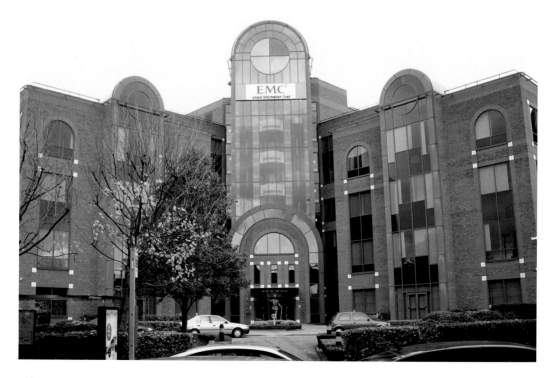

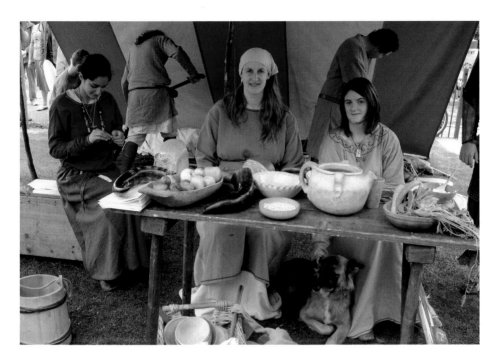

Brentford Carnival

Brentford used to hold an annual carnival to raise money for the Cottage Hospital. The old photograph shows a float at a Carnival in the 1930s. Peggy Shaw is the little girl in the front; Doris Newman the lady on the right. The modern photograph shows Viking ladies in their tent at the Brentford Festival held at Boston Manor Park in September 2010. Events on the day included a mock Viking battle.

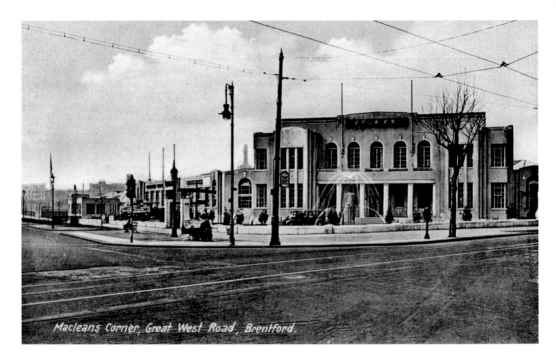

Macleans Corner, Great West Road, Brentford.

Macleans Corner

Macleans, which made toothpaste and indigestion remedies, built its factory on the corner of Boston Manor Road and the Great West Road in 1932. The company was taken over by Beecham in 1938 and the factory went out of production in the 1960s. The building was home to Rank Audio Visual before being demolished in 1997. The massive headquarters of GlaxoSmithKline was built on the site in 2002.

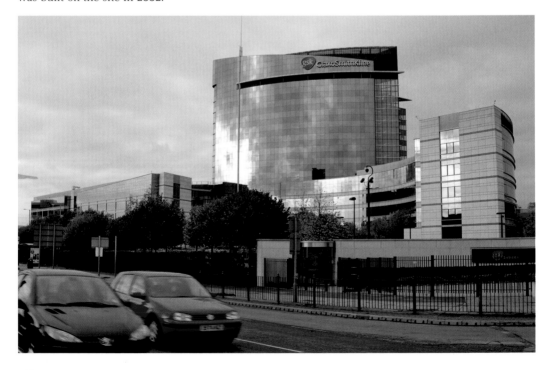

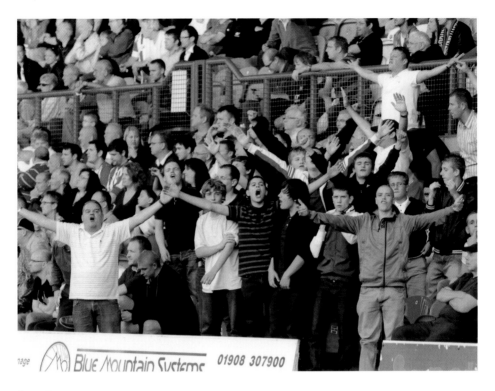

Bees Fans

The old picture shows Brentford Football Club fans at Griffin Park in 1935, watching Brentford play Huddersfield; the modern photograph shows fans in 2010 when Brentford was playing Fulham. Griffin Park, unlike any other football ground in the country, has pubs on all four corners of its ground.

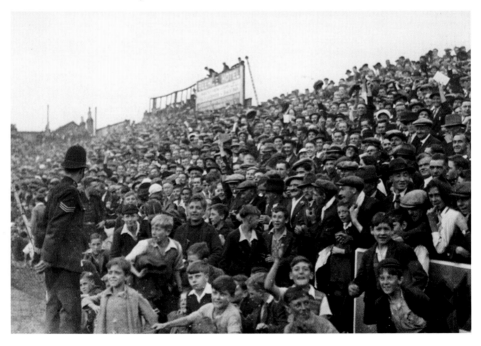

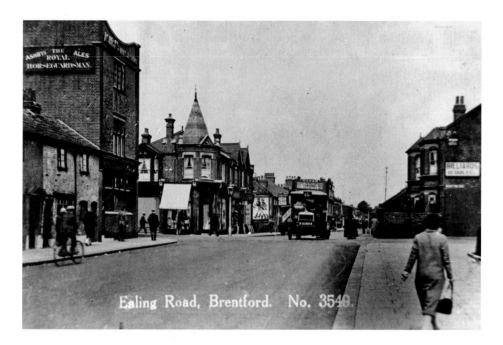

Ealing Road

This photograph of Ealing Road, taken in the 1930s, shows the house called Strawberry Villa on the right. This was the home of Thomas Beach, proprietor of T. W. Beach & Sons, makers of jams and preserves. Beach was the first to discover how to make whole-fruit jam using glass bottles. He sold both the house and the factory behind in 1929 when the firm moved to Hanworth. The house has now gone, replaced by the Haverfield Estate.

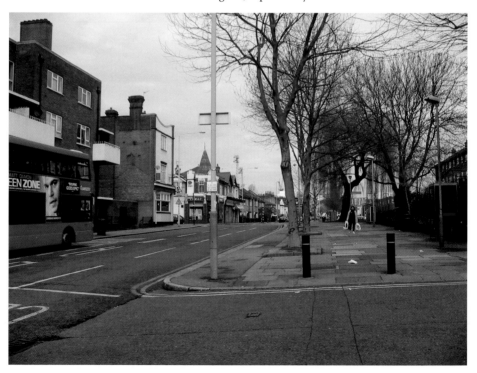

Brentford Outings
Brentford folk outside the Royal Oak pub about to embark on a charabanc outing in the 1940s, and Brentford folk having fun at the Mela held in Gunnersbury Park in 2009. Mela is an Asian word for a gathering or a fair. The Mela has been held each year at Gunnersbury since 2003. It offers classical music, dance, comedy and food stalls as well as a funfair.

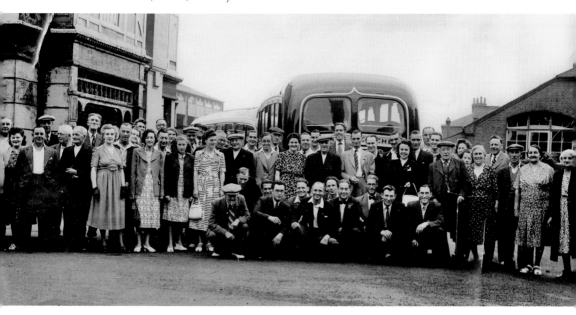

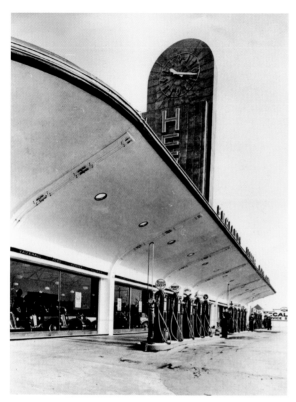

Henly's Forecourt

Henly's, once Britain's biggest motor agency, opened its elegant showroom and service station on the Great West Road in 1937. Henly dealt mainly in Jaguars and Studebakers. The building later became a warehouse and distribution depot for Martini. The distinctive clock tower is all that remains of the original building but even that was substantially rebuilt after a fire in 1989. It now carries the logo of EMC2 which has a building on the Henly's site.

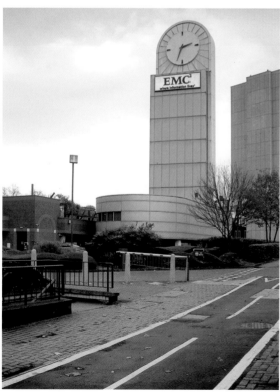

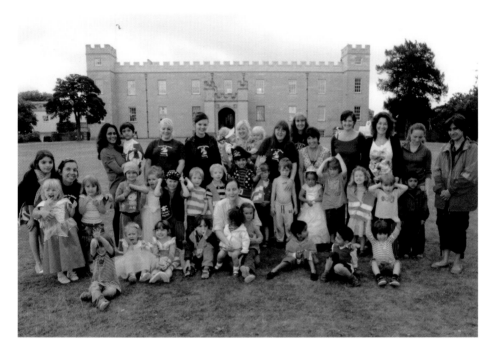

Goat Wharf

The old photograph shows party held in 1945 to celebrate the end of the Second World War. The people are standing outside a substantial house which stood in Goat Wharf, just off Brentford High Street. The site of the house is now occupied by the empty and boarded up office block called Thameside House. The modern picture shows an even more prestigious building, Syon House, with local children taking part in an event to raise money for Barnardo's.

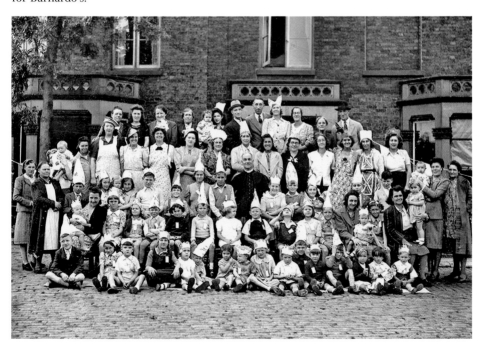

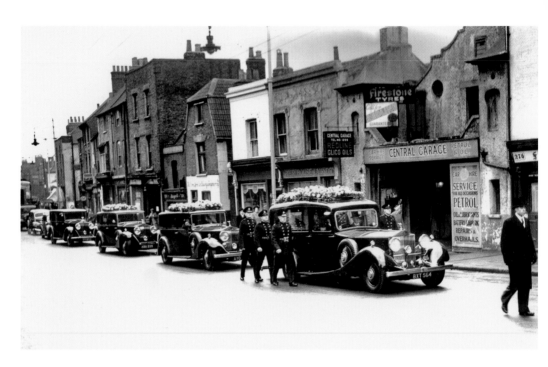

The Funeral of Frank Davis

Frank Davis ran a building business in Brentford High Street and died in 1948. Davis was also a captain of the Brentford Fire Brigade, which is why firemen are walking beside the hearse. The procession is passing the old Coronet Cinema which operated between 1912 and 1928. The flats known as Watermans Court were built on its site in the 1990s.

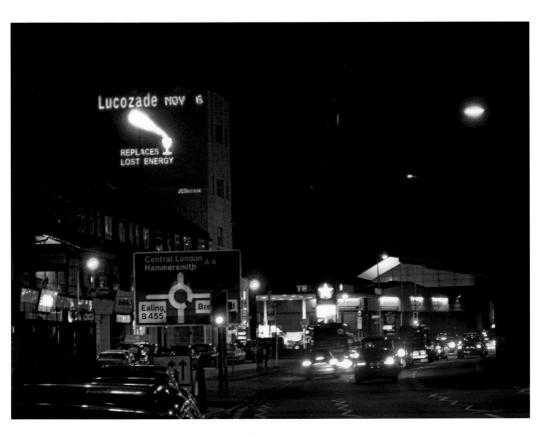

Lucozade Sign

This famous neon sign was
erected in 1954 on one of the
buildings on the north side of
the A4 occupied by Beecham,
which made the product, but it
was taken down in 2004. It was
such a landmark on the road into
London that locals campaigned
for six years to have it put back.
An exact replica was put up on a
building about 250 yards west of
the original site in 2009.

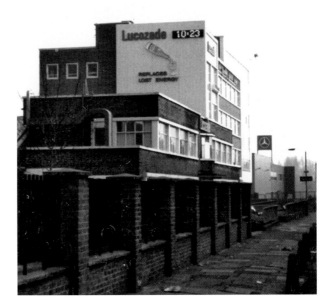

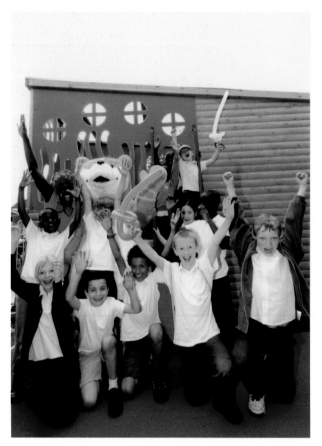

North Road

The old picture shows a street party in North Road to celebrate Queen Elizabeth's Coronation in 1953. The modern photograph shows children celebrating the opening of the new Children's Centre at Green Dragon Primary School in North Road in 2010. Its services include baby massage, yoga and under-fives football classes.

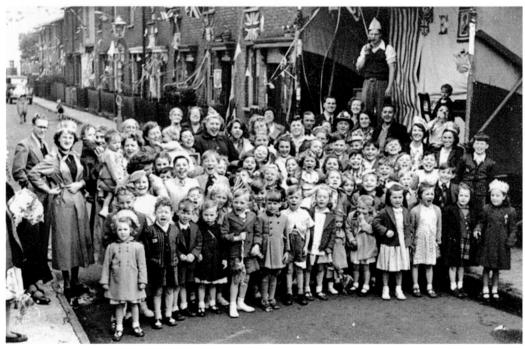

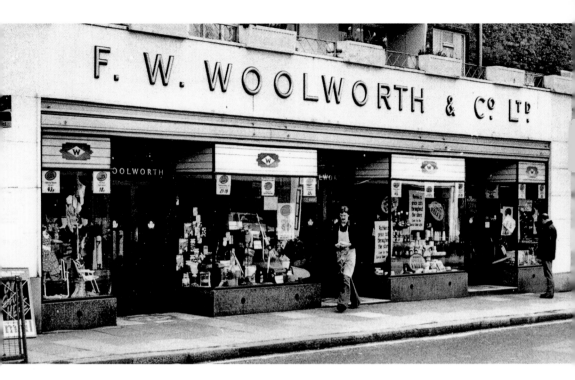

Woolworths

The shop opened in 1955 at 120-122 Brentford High Street but sadly closed in 1978, long before the firm of Woolworth & Co went to the wall. The Brentford Woolworths has been replaced by a number of small shops one of which is a tattoo parlour.

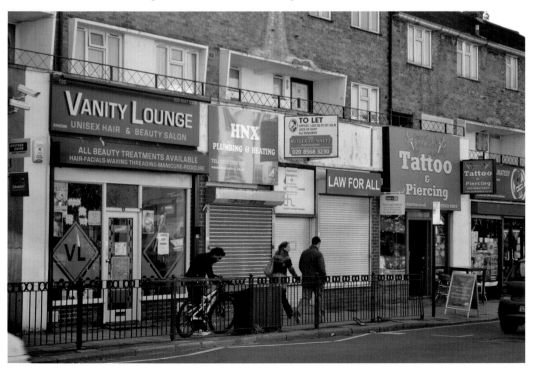

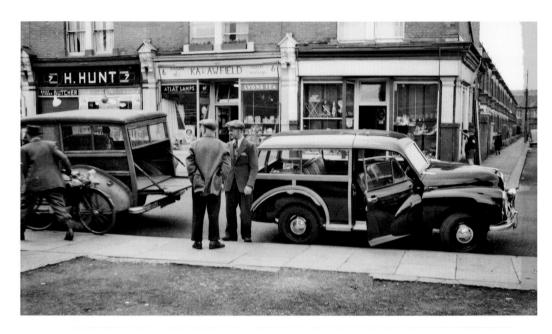

Albany Road Shops

The old photograph of Albany Road at its junction with Mafeking Avenue was taken in the 1950s by James Daubney who ran a greengrocer's shop in Albany Road. The Daubney family ran fruit and vegetable shops in Brentford for fifty years including a shop in Brentford High Street (see p 90). As the modern photograph shows, most of these Albany Road shops have been turned into houses, like so many handy little local shops.

The Monument

It was moved from its original position (see p 57) in 1955 to a new site in Ferry Lane, shown in the old photograph. It was moved again in 1992 to stand outside the County Court. The monument commemorates four events in Brentford's history: Caesar crossing the Thames in 54 BC; a synod held by King Offa in AD 780; King Edmund driving Canute and the Danish army across the river in 1016 and the Civil War Battle of Brentford, 1642.

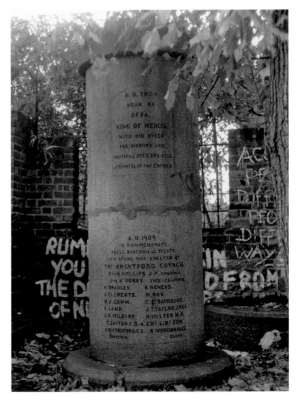

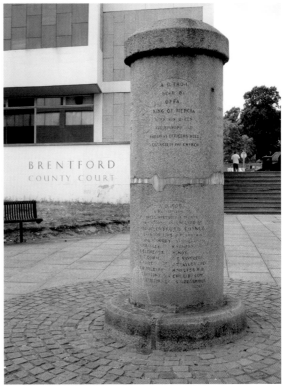

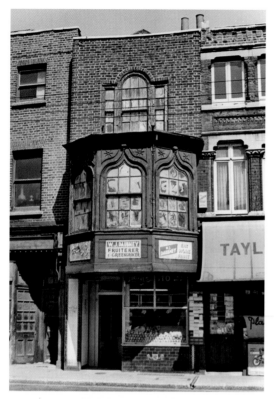

Shop with Oriel Windows

Several of the properties in Brentford High Street had these rather charming projecting upper storeys. The old photograph shows No 216 in 1963 when it was trading as Daubneys, selling fruit and veg. The shop had been a draper's shop, then, in 1913, became a provision store run by the Purkis family. The building was demolished and No 216 is now the bedding department of Goddard's furniture store, which was built in 1970. The Goddard family have been trading in Brentford since 1815. They ran several different businesses – umbrella makers, glass and china sellers, auctioneers and estate agents as well as dealing in furniture and removals.

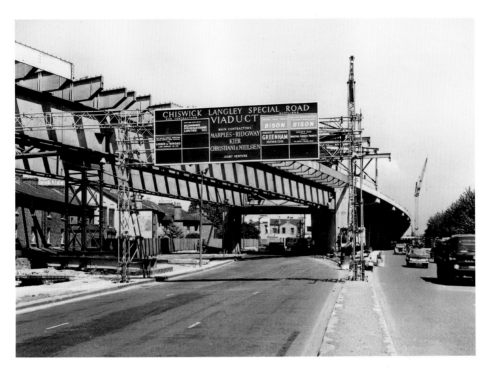

The M4

Work in progress to construct the two-mile elevated section of the M4. This work, carried out in 1964 by Marples Ridgeway, linked the A4 to the M4. At the time it was said to be the longest viaduct in Europe. The A4, originally called the Great West Road, was constructed in 1925 as a bypass to Brentford High Street.

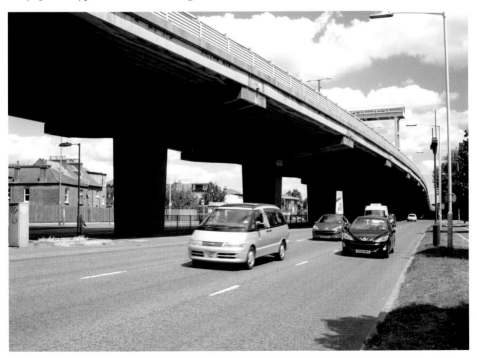

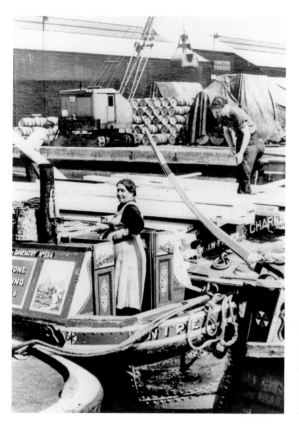

Loading at the Depot
In 1929 the Grand Union Canal
established a depot at Brentford for
the transhipment of cargo between
narrow boats and river craft, and
later canal and road. This photograph
shows Clare Wilson in the stern of
the Willow Wren Carrying Company's
butty boat *Snipe* while it was being
loaded with timber at Brentford in
about 1969. The Depot was closed in
1997 and its site is now occupied by
the Brentford Lock development and
residential narrow boats.

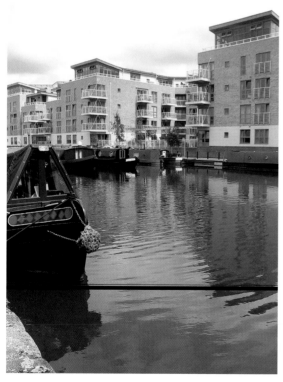

Ferry Lane

The modern view down Ferry Lane shows the Ferry Quays development which has replaced the factory known as Varley Pumps, later Peerless Pumps. The eighteenth-century house jutting out at the bottom was the home of the Rowe family who ran the Thames Soap works which was bought by Lever Bros in 1916.

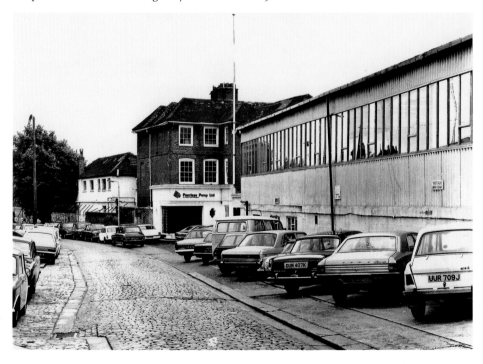

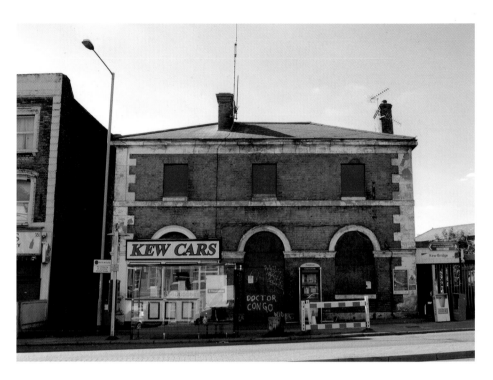

Kew Bridge Station

The station house, designed by Sir William Tite, and now a Grade II listed building, was put up in 1849. It was still in good condition in 1977, as the bottom photograph shows, but it has been neglected and was in a sorry state when the new photograph was taken in 2010.

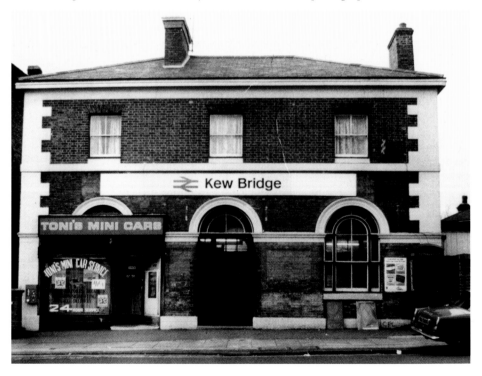

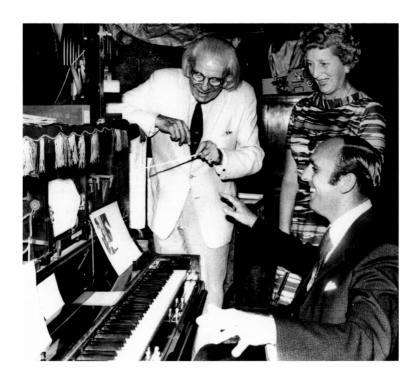

Musical Museum

Frank Holland with the Mayor and Mayoress of Hounslow in St George's Church in 1977. The Musical Museum was formed from Frank Holland's collection of automatic pianos and housed in St George's Church from 1963 to 2009 when it moved to a new building just down the road. The 2010 photograph shows Simon Gledhill playing the mighty Wurlitzer pipe organ which came from the Regal Theatre Kingston.

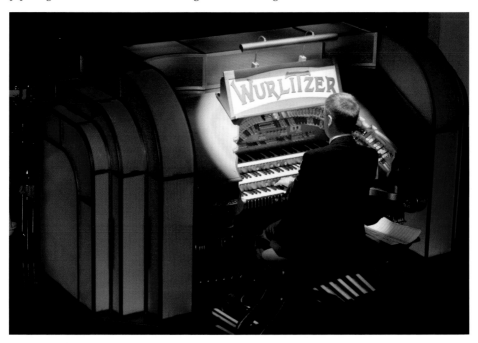

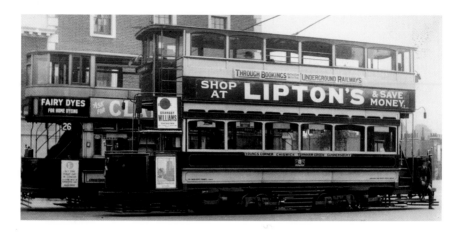

Trams at Kew Bridge
This important crossing at the junction of the main road to the west of England and the bridge going south was the western terminus for trams before tracks were laid to Brentford and Hounslow in 1901.

Acknowledgements

I would like to thank the following people for their different but invaluable assistance: Janet McNamara, Adam Watson, Carolyn Hammond, Peter Hammond, Peter Downes, Patrick McHugh, James Marshall, Hannah Levy, Karen Liebreich, Paul Shaw and Celia Cotton whose Brentford High Street website www.bhsproject.co.uk was very useful.

Most of the old illustrations in this book come from the collection in Chiswick Local Studies and I am grateful to the London Borough of Hounslow for permission to reproduce them. The modern photographs were taken by a number of people, including myself. Apart from the pictures from Chiswick Local Studies and photographs by the author, the illustrations (identified by page number and 'a' for the top picture; 'b' for the bottom picture) are reproduced by permission of the following:

Brentford, Chiswick & Isleworth Times 87a, 94b, 95a; Brentford Football Club 44b; Samuel and Kay Day 88a; Roger Davis 84a; Peter Downes 44a, 46b, 64a, 67a, 72b, 79b, 96; Margaret Drury 23a, 42b; Generalate of the Poor Servants of the Mother of God 61a; Sandra Graves 81b; Gunnersbury Park Museum 15a, 58a, 65b, 71a, 75b, 76a, 78a, 82a, 85b; Peter and Carolyn Hammond 12a, 31a; George Hare 20b; *The Hounslow Chronicle* 26a, 35a, 53a,, 67b, 79a, 81a, 83a, 86a; Hannah Levy 6b, 11b, 16b, 19b, 21a, 33b, 38b, 47b, 57a, 66a, 71b, 87b, 90b; Diana Lockie 77b; Aveen McHugh 17b, 24b, 37b ,55a, 73b, 94a; Janet McNamara 7b, 8b,13b, 14a, 18b, 25b, 28b, 29a, 32a, 40b, 48b, 49a, 52b, 54b, 56b, 59a, 62b, 63a, 65a, 72a, 80b, 92b, 93a; Betty Morgan 69a; The Musical Museum 95b; Arthur Peters 83b; Tony Peters (copyright holder of photographs by the late John C. Gillham) 30a; Ena Stone and Lynn Hayter 86b; Richard Toull 36a, 74b, 39b, 85a; Dreda Trickner 74a; Waterways Archive, Gloucester 50a; Adam Watson 10b, 30b, 41a, 45b, 60a, 64b, 68a, 70a, 75a,76b, 78b, 82b, 85b, 89b, 91b; Bill Wilson/Alan Faulkner Collection 92a; Liz Wilson 58b; Colin Woodward 34.